HITCHIN
THROUGH TIME
Hugh Madgin

AMBERLEY PUBLISHING

Acknowledgements

This book would not have appeared without considerable support from the following: Ian and Patricia Aspinall, Richard Holton, and Mike Hadley of Hitchin Museum who have provided photographs and information. To them I would like to record my grateful thanks. Special thanks are also due to my wife, Cath, for her unfailing support.

First published 2009

Amberley Publishing Plc
Cirencester Road, Chalford,
Stroud, Gloucestershire, GL6 8PE

www.amberley-books.com

Copyright © Hugh Madgin, 2009

The right of Hugh Madgin to be identified as the
Author of this work has been asserted in accordance
with the Copyrights, Designs and Patents Act 1988.

ISBN 978 1 84868 745 5

British Library Cataloguing in Publication Data.
A catalogue record for this book is available from
the British Library.

Typeset in 9.5pt on 12pt Celeste.
Typesetting by Amberley Publishing.
Printed in the UK.

Introduction

Of all the many market towns in Hertfordshire, Hitchin is perhaps the one which best retains the atmosphere and appearance of a 'typical market town'. However, it is unique amongst the market towns of Hertfordshire by being neither on one of the major routes radiating from London nor on a navigable river.

The full story of Hitchin's origin is currently lost from view. Archeaological investigations in recent years have revealed more pieces of the jigsaw, which one day will form an accurate picture of its birth. At present, however, it is not possible to say with certainty whether Hitchin was a *burh* in the days before the country was divided up into counties, administering a large area, including parts of what became Bedfordshire, although its large minster church — the biggest parish church in Hertfordshire — suggests that this may be the case.

The jury is still out as to whether Hitchin is the lost major centre of Clofesho of Saxon times, and there is a paucity of documentary evidence for the years when it appears that the town was laid out with burgage plots around the twelfth or thirteenth century.

The fact that Hitchin was built on a sheltered site, surrounded by hills and just to the south of the prehistoric Icknield Way (which forms its northwestern parish boundary) which points to a Saxon origin, is, however, undisputable. Its main street, stretching from the top of Bancroft in the north and gradually gaining in width until reaching an intersection with what are now Tilehouse and Bridge Streets in the south, was not part of a route to anywhere else — it was simply a destination in itself.

The lack of a market charter date for Hitchin suggests that its market was well underway before the Crown took a controlling interest in granting such privileges and so, very likely, it dates back to before the Norman Conquest.

For centuries, until at least the middle of the eighteenth century, Hitchin was the second largest town in Hertfordshire after St Albans. While it is now well down the rankings in size, it remains the centre for North Hertfordshire, with a hinterland that its large neighbours of Letchworth and Stevenage, expanded massively in the twentieth century, do not possess.

In the eighteenth and nineteenth centuries, Hitchin had a strong Nonconformist presence and an influx of influential Quaker families, such as the Lucases, Ransoms and Seebohms, did much to develop the town's banking, brewing and other industrial activities. After the Second World War, employment opportunities at the Lister Hospital and businesses such as Russells tannery, helped attract new residents from the Commonwealth.

Hitchin has undergone great changes in the past 100 years, which it is hoped the photographs of this book will illustrate, but these are, in the main, changes of detail. The market town charm, in which writers such as Reginald Hine and artists such as F. R. Griggs have revelled, remains and looks set to continue, even though plans for major developments of tens of thousands of new houses are afoot around Hitchin at the time of writing.

<div align="right">Hugh Madgin, 2009</div>

About the Author

Hugh Madgin has been fascinated by the history of Hitchin for years. He is the creator of hitchinonthenet.com

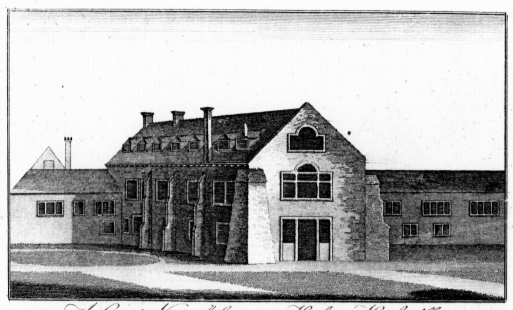

The Garden View of the PRIORY at Hitchin in Hertfordshire.

Hitchin Priory

Hitchin Priory was founded in 1317. It has been much rebuilt over the years and originally was modest in size — the engraving shows it as existing in the eighteenth century. Today, the earliest part to survive is part of the cloisters, which adjoin what is now the reception area of the Priory complex. These two-centred arches are understood to date from the fifteenth century.

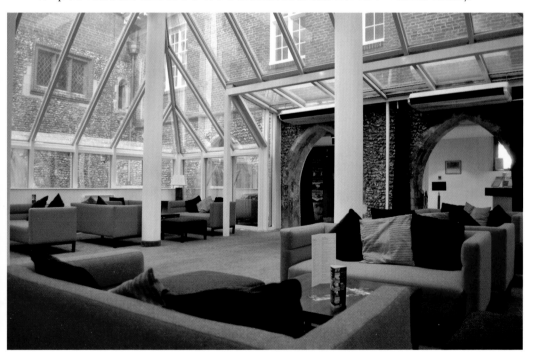

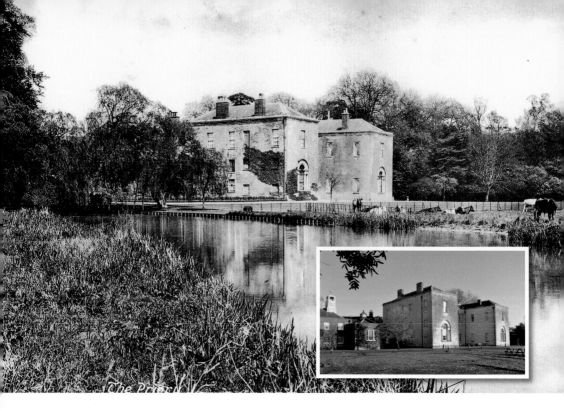

Hitchin Priory (continued)

After the dissolution of the monasteries in 1539, the Hitchin Priory passed into the ownership of the Radcliffe and then Delmé-Radcliffe families, in whose hands it remained until 1963. Today a conference centre and hotel, the main building was built by John Radcliffe in 1770-1. The old view across the River Hiz is obscured today by trees, although some of the house can be seen reflected in the water.

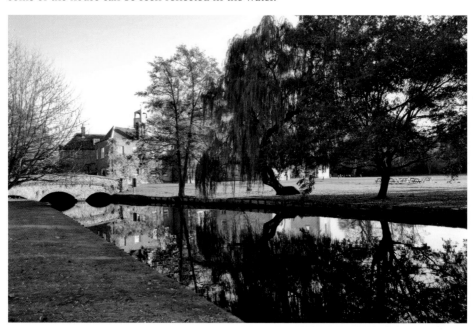

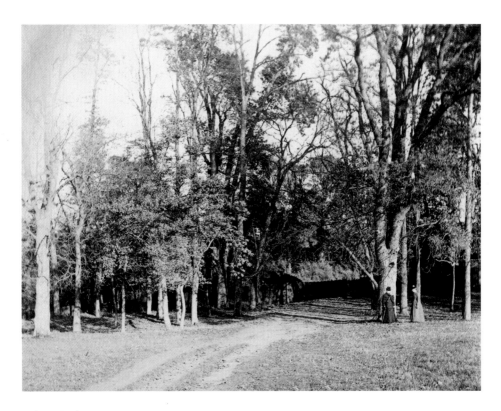

Priory Park

Until severed by the Hitchin bypass in the early 1980s, the Priory Park brought rolling countryside right to the heart of the town. This corner of the Park adjoined Gosmore Road and is seen in 1885. Today, the footpath from Gosmore Road runs alongside the bypass (Park Way) alongside a chain line fence.

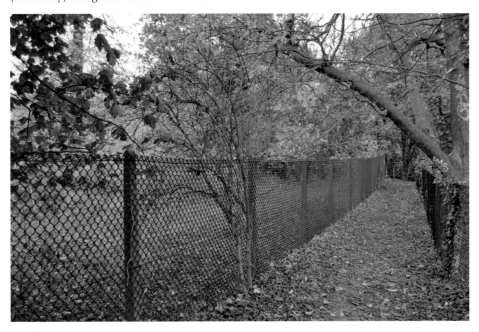

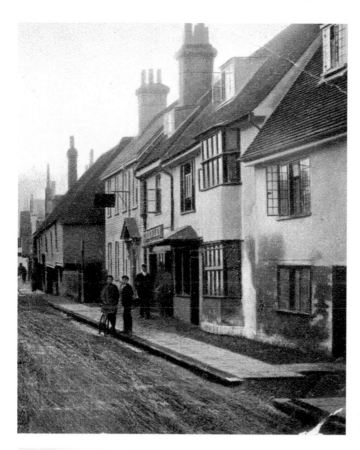

Priory Gatehouse
The priory had a gatehouse by the ford in what is now Bridge Street; it is believed to have been where No. 37 Bridge Street now stands. This is the building with the bay window, which today is The Hair Shop.

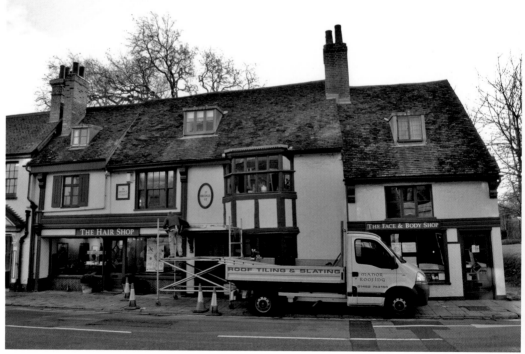

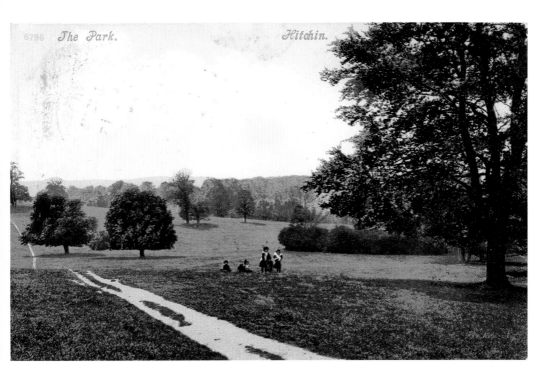

Priory Park *(continued)*

The view across the Priory Park looking towards Charlton. The park was increased in size by John Radcliffe in the 1770s, and he closed off the road from Park Street to the Tatmore Hills and Preston as part of the process. Public paths through the park remained and still do so today.

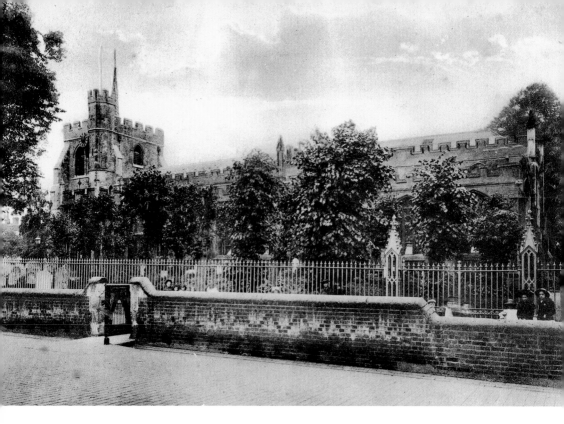

St Mary's Church

Hitchin church is said to date from the reign of King Offa (757-796), although foundations uncovered indicate that it may well go back to the seventh century. Originally, it was dedicated to St Andrew but had been rededicated to St Mary by 1490. The earlier of these two views of the south side of the church was taken from the grounds of St Mary's Schools, which were demolished at the start of the 1970s and whose site is now part of Hitchin Market.

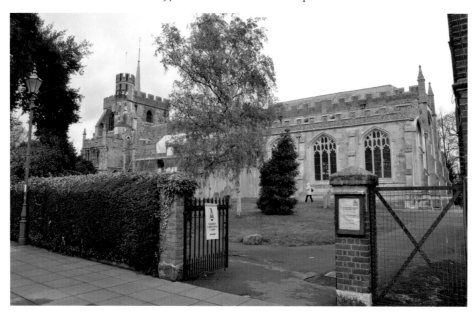

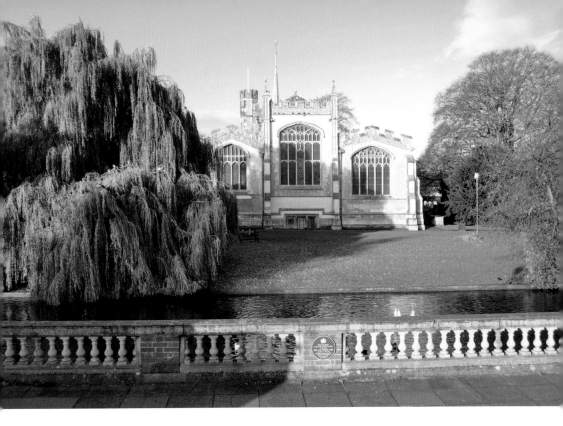

St Mary's Church *(continued)*

The eastern end of St Mary's church today is close to the River Hiz; prior to the creation of St Marys Square in the 1920s, the river wound further eastwards to roughly where the camera is. The chancel window (centre), with its five lights, dates from the fifteenth century, as do the north and south chapels built on either side.

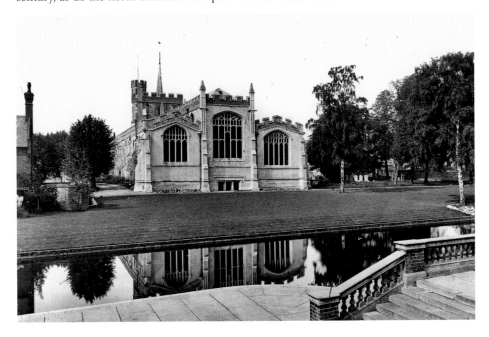

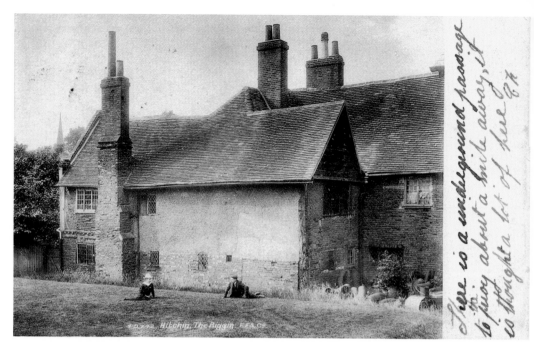

The Biggin

Just across the river from St Mary's stands the Biggin. This was founded as a Gilbertine Priory in 1361 and, although much rebuilt, contains timberwork dating from then. From 1654, it was made into almshouses under the will of Joseph Kempe for 'Ten auncient or middle aged women' and 'Four poor children' and remained as such for more than 300 years. The wing seen in the earlier view on the south side of the building was demolished in 1907, at which time, it was said that a fourteenth-century window was uncovered.

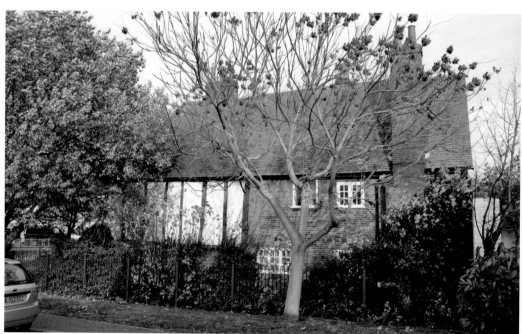

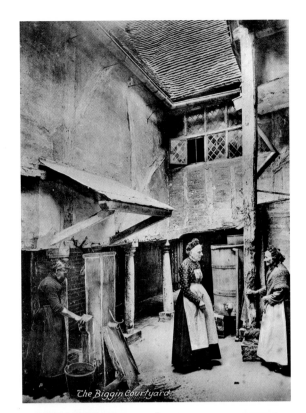

The Biggin Courtyard.

The Biggin *(continued)*
The courtyard of the Biggin
contains a Tuscan Colonnade, a
very unusual feature. The pump
in the earlier photograph was
removed during renovations at
the turn of the 1960s — today's
residents enjoy 'all mod-cons'
and no doubt would bridle at the
description of 'auncient'.

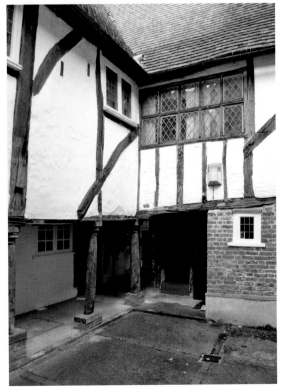

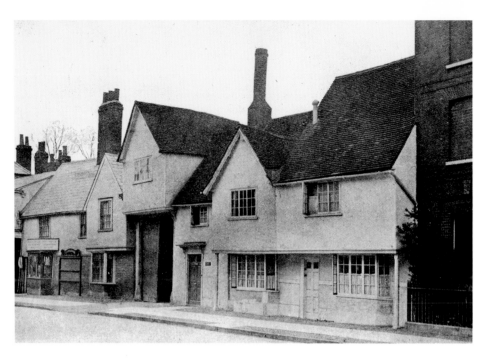

Bancroft

The long ancient street around which Hitchin is built starts at the junction of Bancroft with Fishponds, Ickleford and Nightingale Roads and runs south to Hitchin Priory. Getting progressively wider as it goes, its broad expanse has been infilled over the centuries and today the street is divided up into Bancroft, High Street, Market Square, Sun Street and Bucklersbury. This range of buildings on the east side of Bancroft includes No. 104, with its high gateway; for more than a century the entrance to William Ransom & Co., the pharmaceutical manufacturers, and still today the registered address of the company.

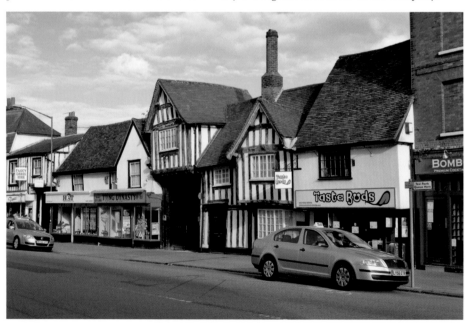

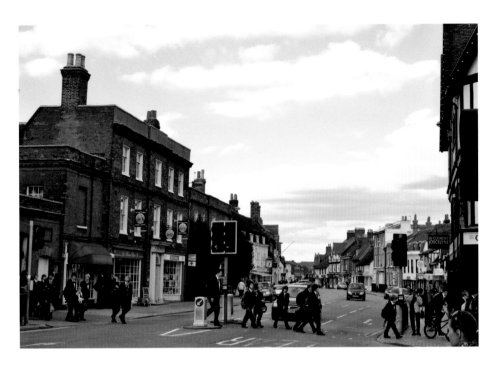

Bancroft Looking North

Bancroft contains many fine timber-framed buildings, some of which have been 'Georgianised' with brick frontages. The Woodlands, nearest the camera on the far side of the road, is more modern; it was the Girls' Grammar School for nineteen years, when, following the closure of the old Free School in Tilehouse Street, Hitchin obtained a grammar school each for boys and girls in 1889. The boys' school was built on land to the rear of The Woodlands; today the gateway at the side of the house is still busy with pupils at the end of the school day.

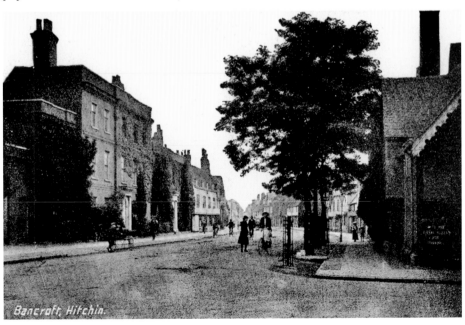

Bancroft, Hitchin.

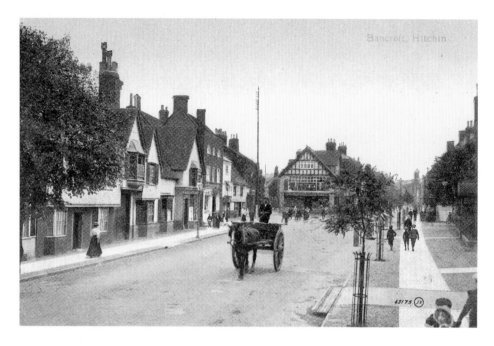

Bancroft Looking South

This part of Bancroft was used for Hitchin's weekly livestock market until 1904. The old timber-framed buildings on the left in the earlier view were casualties of the 1960s; the buildings in the centre of the picture are the northern end of the infill of the ancient street between the Churchyard and what is now High Street. The white painted building immediately above the bus shelter, on the right-hand side of the street, is the former Guild House, now Nos. 2-5 Bancroft, including Lloyds Bank cashpoint and Visioncare.

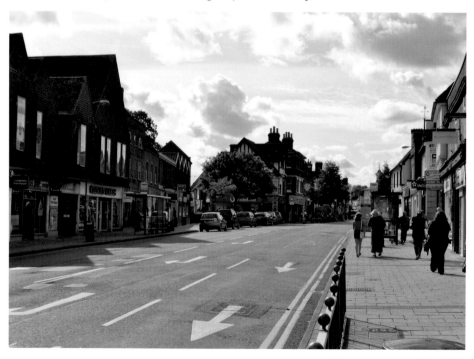

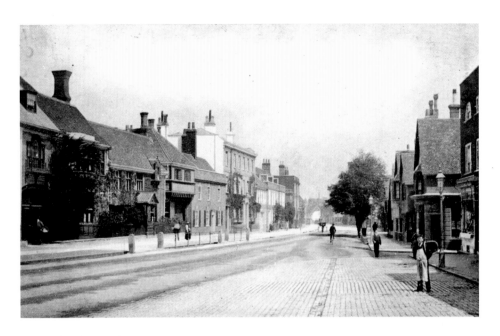

Bancroft, The Croft

The house on the left-hand side of the street in the earlier view is The Croft, which dated back to the 1500s at least and is thought to have been a woolstapler's hall. In the nineteenth century, it was the home of banker James Hack Tuke. His family was linked closely with the development of Barclays Bank; three successive generations were chairmen of the company, the most recent being Sir Anthony Tuke, chairman 1973-1981. The Croft was demolished in 1964 and replaced by shops, although the frontage of the new buildings replicated some of the features of the old house.

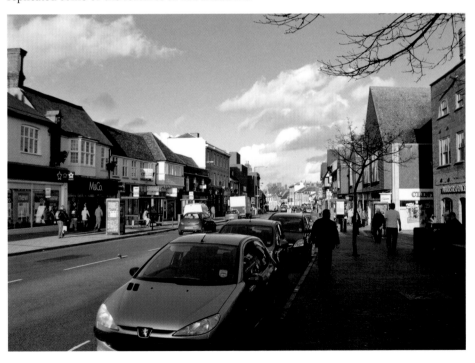

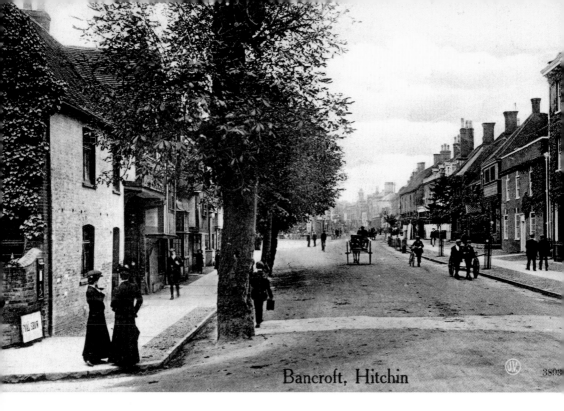

Bancroft, Hitchin

Bancroft Looking South

This part of Bancroft was redolent with timber associations, long after its mature trees were felled in the second decade of the twentieth century. The nearest house to the camera and the old timber-framed gateway were replaced with a three-storey mock timber-framed shop in the 1920s. The ancient gateway at No. 86 Bancroft had formed the entrance to the works of P. H. Barker & Sons, manufacturing joiners. Barker's remained, with an entrance off Hermitage Road, until 1962.

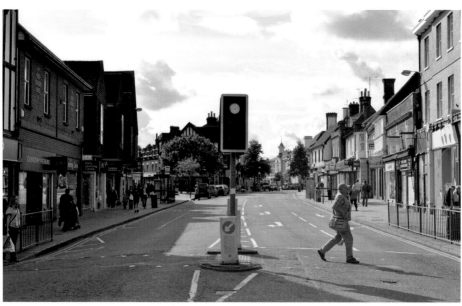

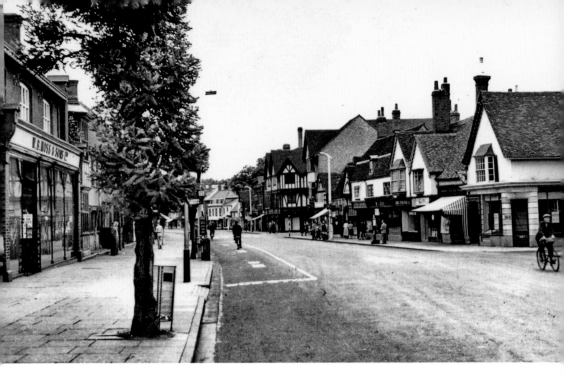

Bancroft Looking North

A last look at Bancroft, showing on the left the shop erected by the renowned Hitchin firm of W. B. Moss in 1911. The Moss family entered the grocery business with a shop in Stevenage before moving to Hitchin in the 1850s. Their business grew rapidly. In 1868, they built the three-storey building at No. 13 High Street, which is now Thomson; they took over the former Trooper pub next door, demolished in 1899 and replaced with the gabled building seen in the centre of the views on page 16. At this time, they had also shops in Nightingale Road, Fenny Stratford, Otley and Ripon, plus a slaughterhouse in Portmill Lane. By the 1950s, they had a presence in Stevenage again, but were eventually taken over by International Stores.

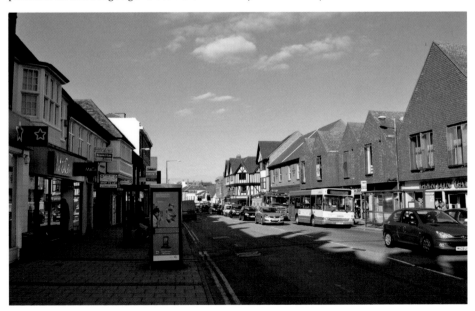

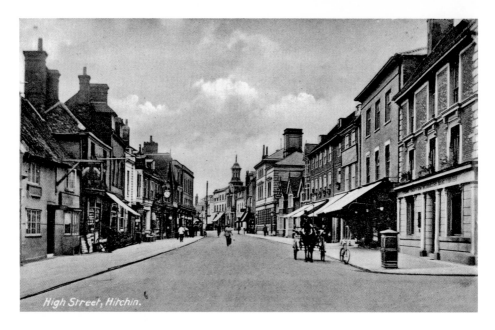

High Street

The High Street is seen here from the junction with Brand Street. At the start of the twentieth century, there were three pubs on the east side of the High Street, the last to close being the nearest to the camera, the Three Horseshoes. This was a Phillips of Royston house. Opposite, No. 11 High Street, today Café Rouge, was rebuilt in 1834 as John Thompson's drapery business, with a vast library on the first floor. This was, for many years, the depository of the British & Foreign Bible Society and attracted visits from writers Bulwer Lytton and Matthew Arnold. In latter years, the first floor was the home of Hobleys caterers; it is now the Regent Cottage restaurant. The shop downstairs was Hepworths outfitter until 1986.

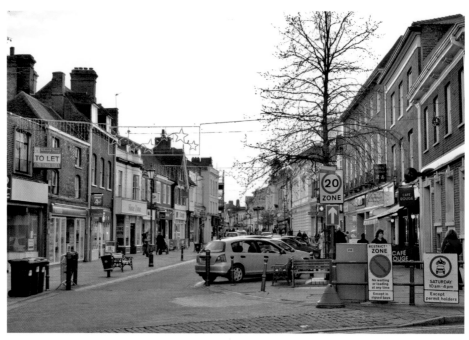

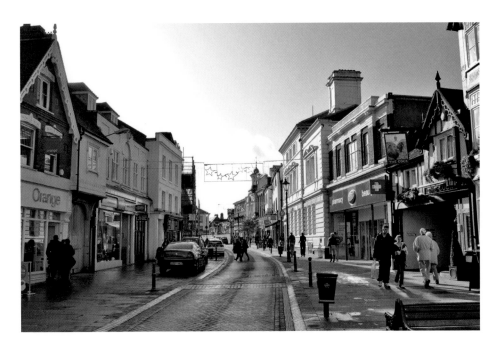

High Street *(continued)*

Hitchin High Street was originally called Cock Street, after the Cock Hotel, which today is the last remaining old-established drinking place in the street. Beyond the Cock, the premises of Barclays Bank are distinguished by the most enormous chimney. Built in 1845 on the site of the failed Piersons bank by Sharples, Exton & Lucas and extended towards the Cock a few years later, the bank became one of the main constituents of Barclays Bank when the latter was formed in 1896. The cupola of the Corn Exchange is in the middle distance.

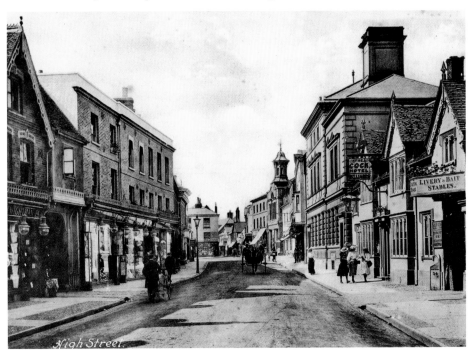

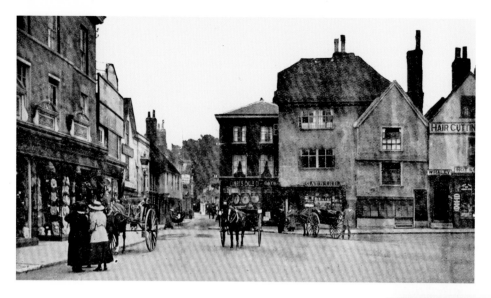

Market Place

Hitchin's status as a market town dates back, probably, to before the Norman Conquest. Until 1939, the market was held in the Market Place, which was thus the commercial centre of the town. At the south-eastern corner, Sun Street leads away, the ancient Angel Inn being visible behind the lady crossing the road with a pram. Occupying an old three-storey building believed to have once been a drovers inn, the jewellery business of W. B. Gatward & Son Ltd dates from 1760 and is understood to be the oldest family-owned retail jewellers in the country. The inside of a Gatward watch of 1879 shows the mark of Cornelius Willson Gatward. The buildings on the east side of the Market Place were dominated by the department store of George Spurr, which closed in the 1960s, to be replaced by the Churchgate development.

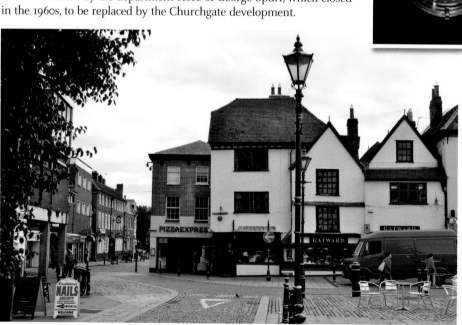

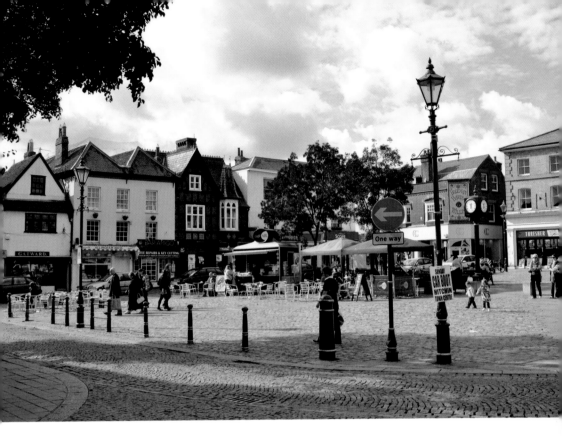

The South Side of the Market Place

In the earlier view, Mr Brolia, the ice cream seller from Letchmore Green, Stevenage, is plying his trade. No. 22 Market Place (behind the man on horseback) was Montgomery's butcher's shop — a century later, it is still a butcher's, run by Allingham Bros. On the far right is the premises of Timothy Whites, the chemists, who would later take over the Woolworth's shop in the High Street.

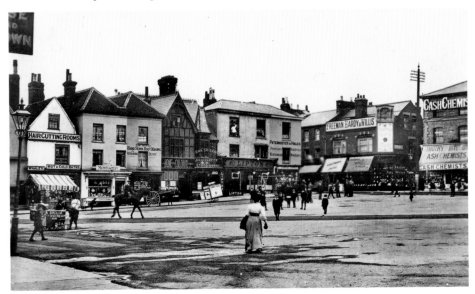

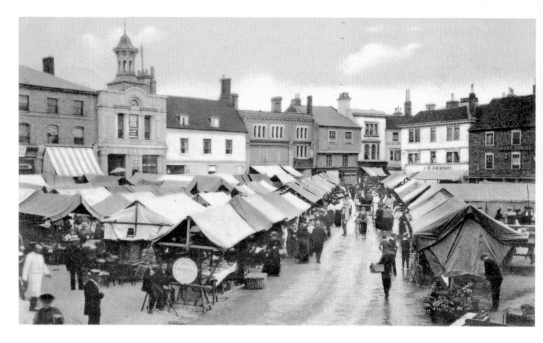

Market Place Looking Towards the High Street

The large hip-roofed building on the left (which would contain the shop of Timothy Whites) was originally one of two iron founders to flank the Corn Exchange in the Market Place. Thomas Perkins started the enterprise in 1864; the company later became Burlingham Innes & Paternoster and then G. H. Innes & Co., whose cast iron gratings can still be seen around the town. In 1917, G. H. Innes went into partnership with G. W. King, who would open a large works close to the railway station.

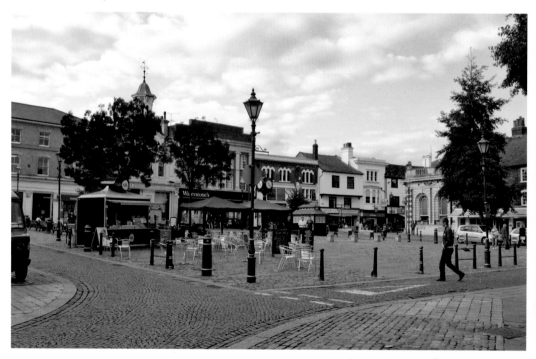

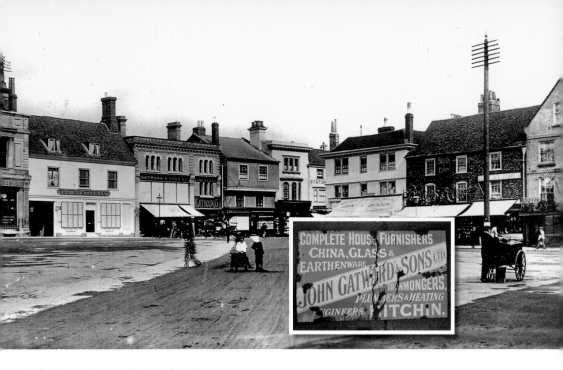

The Swan Ironworks, Market Place

The second of the Market Place's iron founders was the Swan Ironworks of John Gatward & Sons Ltd, a branch of the same family as the jewellers. This was established at the former Swan Inn at 33 Market Place in 1884, having previously traded next door at Nos 1 and 2 High Street. The company supplied a wide range of ironmongery, gas lighting equipment and telephones in the late 1890s, as well as household furnishings. Gatwards also fitted up houses with electric and pneumatic bell systems. The foundry was in the former yard of the Swan, which became The Arcade in 1927. Gatward cast iron gas stopcock covers are still to be seen on the streets of North Herts.

The former Swan was heavily rebuilt by Gatwards, with a yellow brick frontage and plate glass windows to both ground and first floors and distinctive triple-arched sash windows on the second floor. Despite this, and the fact that a complete new roof was put on in 1961, the core of the old Swan remains, as anyone entering The Arcade and looking upwards to see the ancient joists will notice.

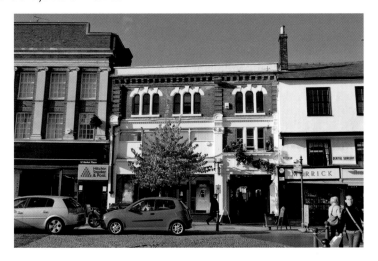

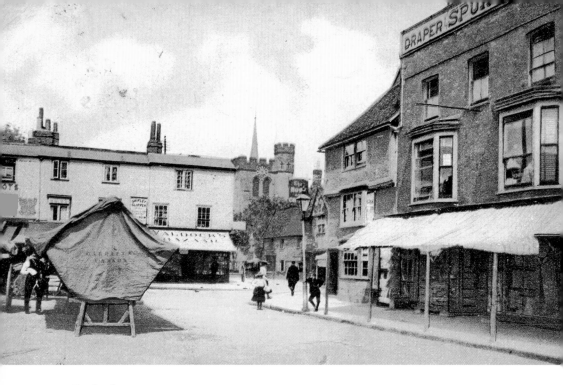

Starbucks

The north-eastern corner of the Market Place. The tilt of the nearest stall bears the name of Garratt & Cannon, the Hitchin sweet manufacturers that had a factory in Bancroft and a shop at Churchgates. The buildings which comprise Starbucks were, between the wars, the location of costumier Maison Gerard, during which period they acquired their faux timber framing. The Rose & Crown prior to rebuilding is seen next to Spurrs. This pub was completely rebuilt in the early 1930s by the brewer J. W. Green of Luton.

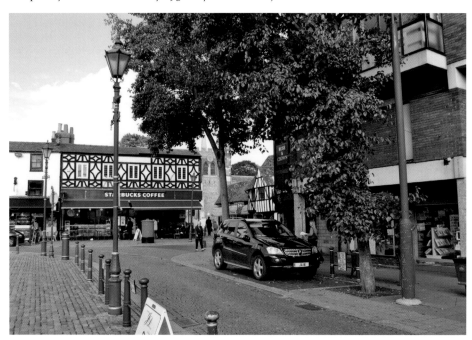

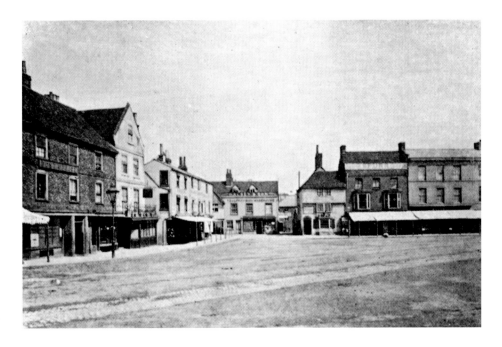

Market Place *(continued)*

The nearest building to the camera was Hitchin's main post office when the earlier view was taken in the late 1890s. The tall building with its gable facing the street is the Red Cow pub, which today is Phase Eight Fashion & Design. The old photograph shows how the main thoroughfare was diagonally across the Market Place to Sun Street. This was changed to a one-way system with a car park in the centre, and then, in the early 1990s, the whole area was covered with rather uncomfortable cobbles, seen here receiving remedial attention behind green screens.

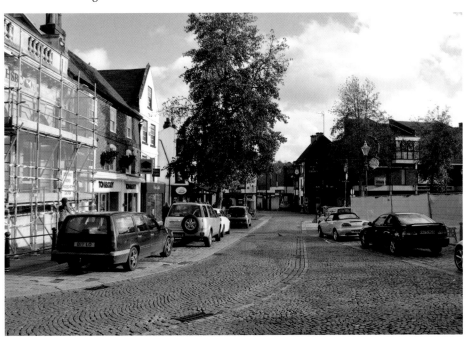

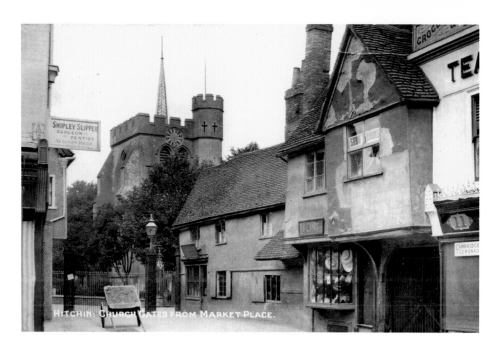

HITCHIN: CHURCH GATES FROM MARKET PLACE.

Church Gates

The churchyard was provided with gates that were closed nightly and were installed in 1828 to prevent the robbing of bodies from graves. The old buildings to the right have been extensively altered and once contained the studio of H. G. Moulden, a prolific photographer of the town a century ago. The town's war memorial was erected in the 1920s and the gates removed, but their memory was acknowledged in the naming of the Churchgate shopping centre, which was built at the start of the 1970s.

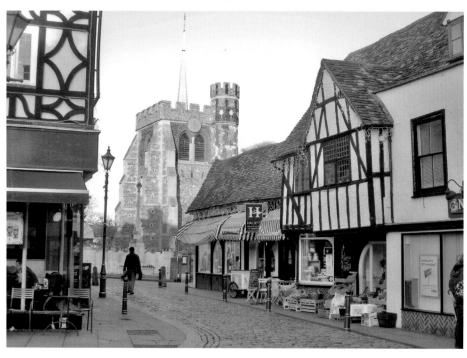

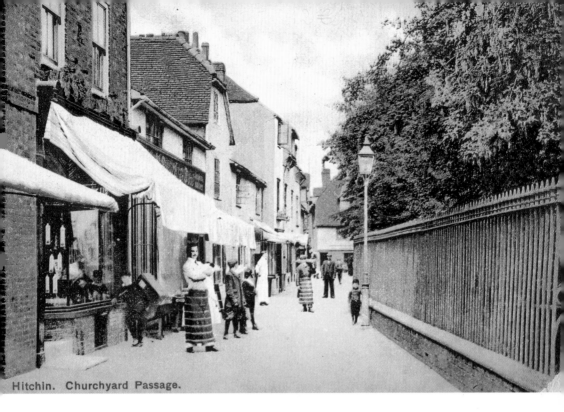

Hitchin. Churchyard Passage.

Churchyard

The infill buildings between what is now the High Street and Churchyard contain a number of interesting old structures, and today, Churchyard remains a charming thoroughfare comprised of individual shops. The cast iron railings around St Mary's went in the 1930s. No. 3 Churchyard, which is nearest the camera, was, for many years, the drapery and ladies outfitting business of C. W. Morris, which rebuilt the building to its current profile.

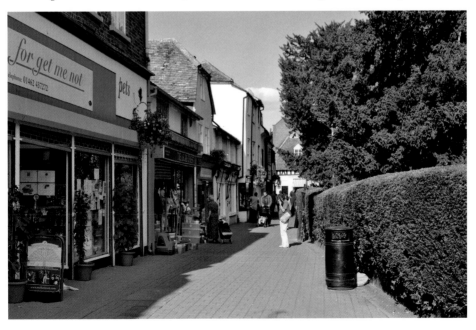

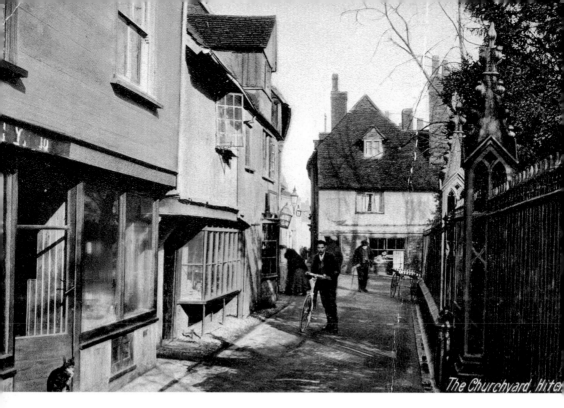

The Churchyard, Hiter

Churchyard/Golden Square

The building closest to the camera was once the churchyard's only pub and for many years afterwards was Howell's newsagents and bookshop. The gap in the buildings in the distance leads through to Bancroft. This thoroughfare was called Golden Square in the nineteenth century, a corruption of Gilden Square, a reference to the Guild House in Bancroft.

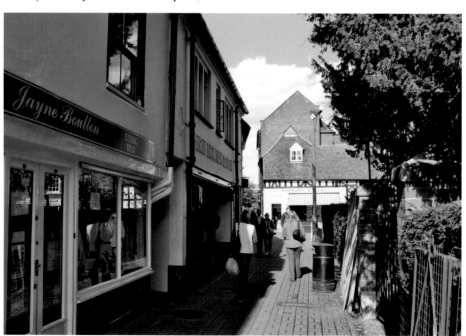

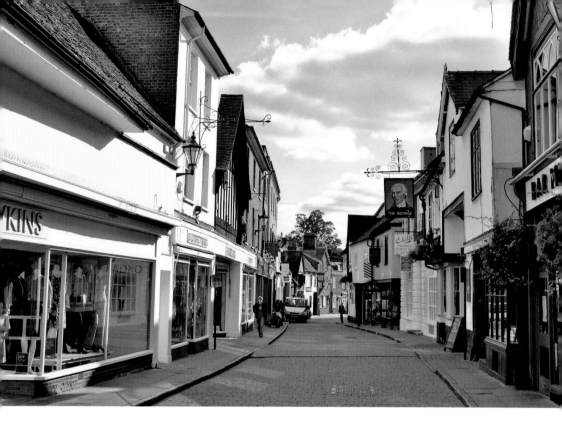

Bucklersbury

The buildings on the left form the western side of the infill between Sun Street and Bucklersbury. One of Hitchin's well-established businesses, the department store Hawkins has expanded over the years along Bucklersbury, into the building in the foreground, which was, for many years, International Stores and has been pared back below eaves level, producing a wider street at this point.

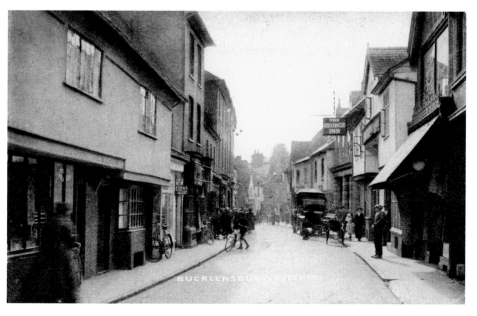

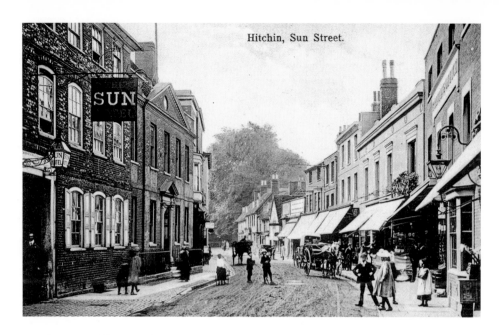

Sun Street Looking South

Although there have been other claimants to the title of Hitchin's principal inn — cases could be made for the Cock, the Red Lion and the Angel in earlier centuries — the Sun Hotel has occupied pole position since the 1700s. Its erstwhile neighbour, the Angel, which was demolished hastily in 1956 after the failure of a major beam, had given its name to the street when the thoroughfare was created by the infill building between here and Bucklersbury. By the time that the Sun received its brick frontage early in the eighteenth century, the road had become Sun Street. The earlier view shows the bunch of grapes carved by Walter Whiting, fixed to the bracket of the inn sign. Next to the Sun is the house of Marshall & Pierson's Brewery, which today is Hitchin Conservative Club.

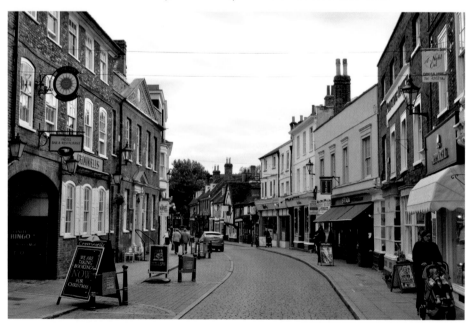

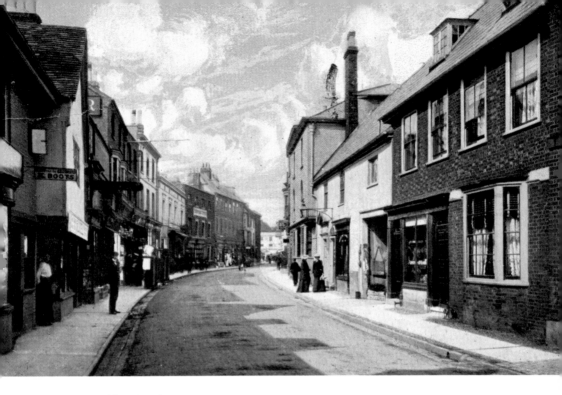

Sun Street Looking North

When the Angel was demolished it was thought that this would allow Sun Street to widened to a uniform width; however, as these views show, the carriageway has actually been narrowed! The Sun Hotel has been joined by a number of restaurants and bars in recent decades and, in a yard to the right, by the Market Theatre. The large pink building on the right is Roslyn House. This was a private school in the nineteenth century.

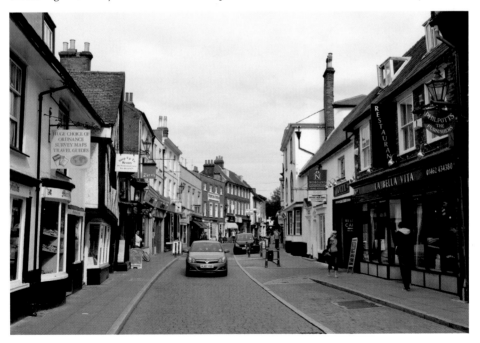

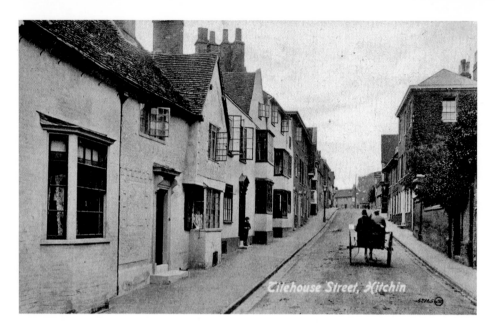

Tilehouse Street, Hitchin

Tilehouse Street

The western exit from the town to Offley and Pirton was from Tilehouse Street. A busy road as motor traffic increased exponentially from the 1930s to the 1970s, travellers had good opportunity to examine the attractive buildings as they waited for the traffic lights at the junction with Old Park Road to change. Since the opening of the Park Way bypass, the eastern part of Tilehouse Street, seen here, has become something of a backwater and its western section, now separated from the rest, has become known as Upper Tilehouse Street.

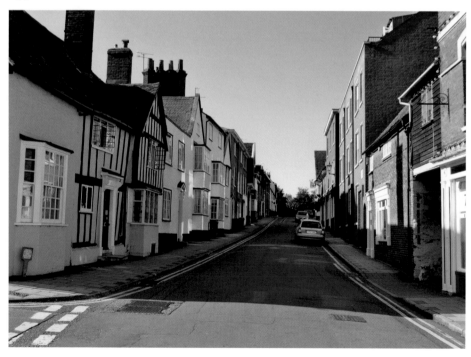

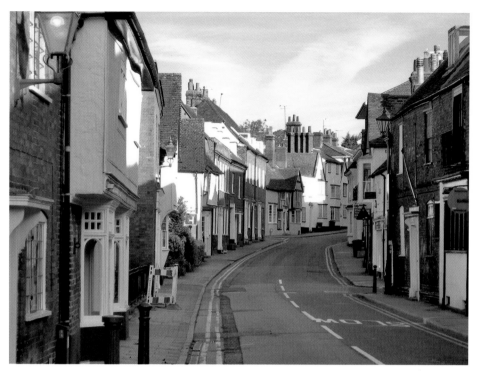

Tilehouse Street *(continued)*
The earlier view shows a flock of sheep in Tilehouse Street. By the time that this photograph was taken by H. G. Moulden, such movements of stock were local. However, before the railway transformed long distance transport, drovers took their animals hundreds of miles from the highland areas of the country to the great markets of London and the South East. The name of the Highlander pub in Upper Tilehouse Street is thought to be a reference to this.

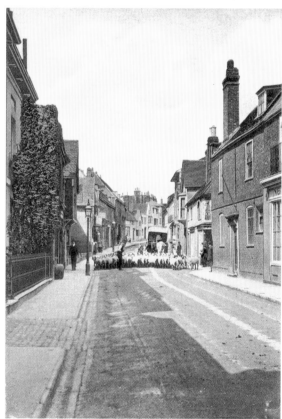

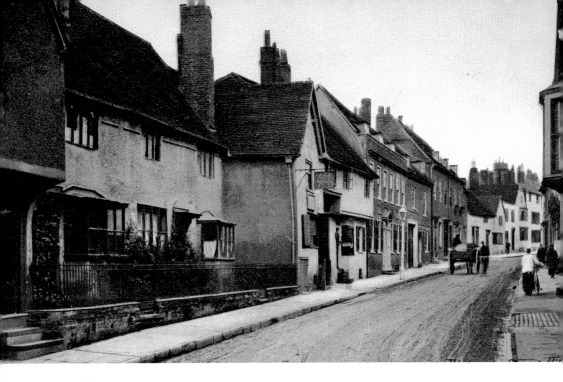

Tilehouse Street

The lower end of Tilehouse Street contains some fine old buildings. In the centre of the old photograph can be seen the Three Tuns — this was a Sworders of Luton pub until 1897, although Pierson's Bucklersbury Brewery, over whose gateway can be seen the bay window on the right, was opposite. After closure in the J. W. Green era, the Three Tuns was, for many years, Harding's wholesale newsagents. It is now a private house. Across the gateway from the Three Tuns was George Day's basket making shop, which survived well into the 1950s.

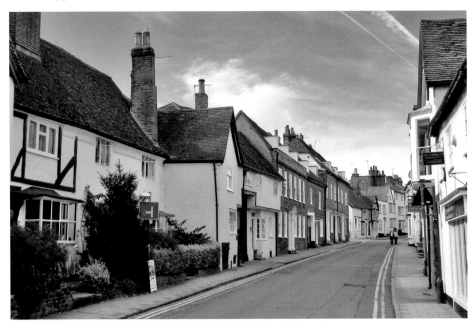

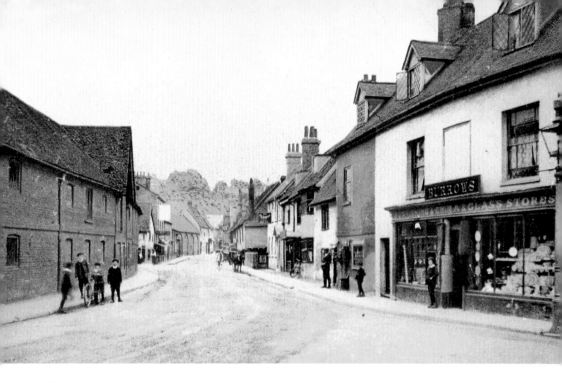

Bridge Street

The corner of Bridge and Sun Street was dominated by the brewery of W. & S. Lucas Ltd, whose brick buildings are seen at this site. Brewing had been undertaken here since 1676 at least, by the Draper family. The brewery came into the hands of William Lucas in 1736 when its owners were unable to repay a mortgage they owed him. The brewery was largely rebuilt in 1771 when the buildings seen here were erected. After sale to the Luton firm of J. W. Green in 1923, the brewery closed almost immediately, much of it becoming Sale's garage. Nos. 39 and 40 Bridge Street, seen on the right in the historic photograph, were demolished around 1960 to open up the approach to Hitchin Priory.

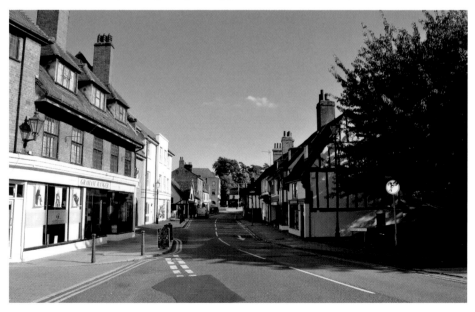

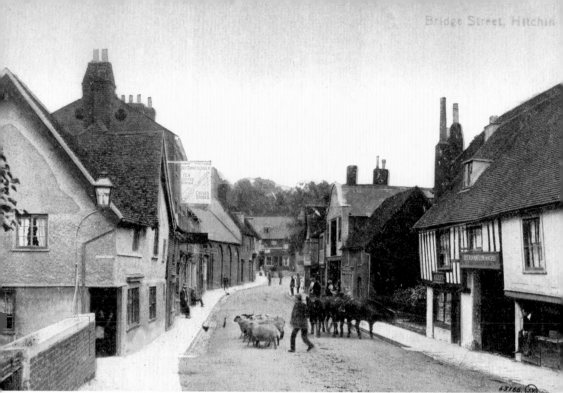

Bridge Street

Looking east along Bridge Street as sheep and cattle pass in the earlier view. The building to the left of the bridge was the Anchor beerhouse during the nineteenth century and in the twentieth, it was the Bridge Café for many years. A. G. Bottoms, who later would run the Hill View Hotel, which was at the far end of the street, in the building that used to be the Bull, was here in the 1920s. Prior to the construction of the Hiz Bridge, Bridge Street was another road taking its name from its principal inn, being known as Bull Street.

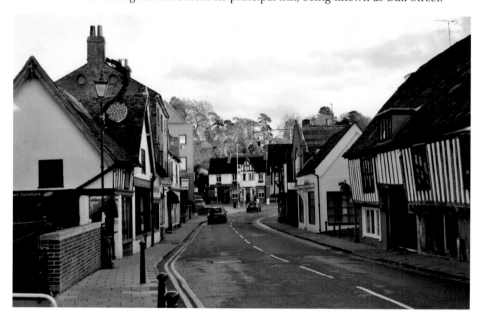

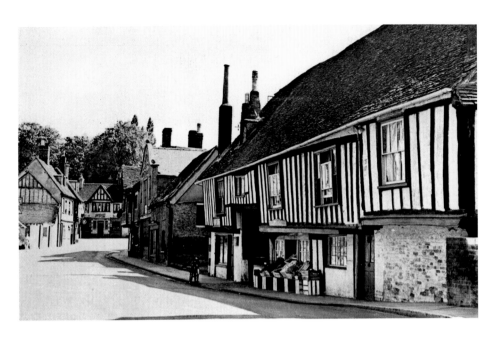

Bridge Street *(continued)*

The large timber-framed building next to the river, on the south side of Bridge Street, was formerly part of the priory estate of the Delmé-Radcliffe family. It won an award when it was extensively refurbished in 1972. Losing its plasterwork in stages during the first half of the twentieth century to expose the timber framing, it is unusual in being jettied on two adjoining fronts; those facing the street and the river, thus requiring a diagonal member known as a dragon beam. No. 31, the portion furthest from the camera, was Furr's sweet shop in the middle years of the twentieth century; the Furr family occupied a number of buildings in Bridge Street over the years. In the middle distance, the jettied gable of the former Royal Oak can be seen projecting into the street.

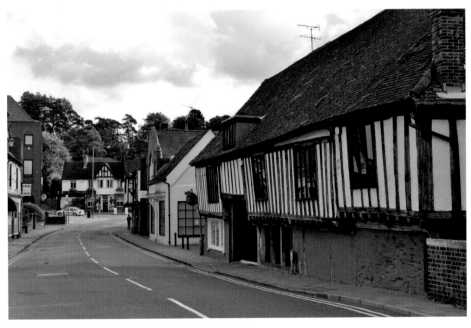

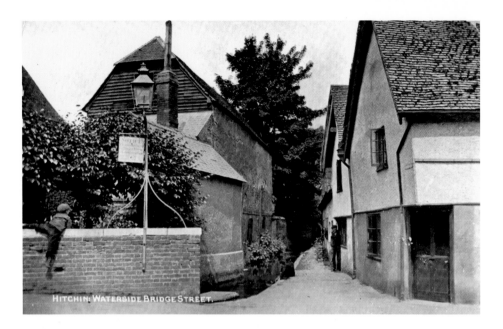

Bridge Street Bridge

Before a bridge over the River Hiz was built, the river was crossed by a ford next to No. 32 Bridge Street. Owing to the size of the river, the Hitchin bridge is a rather modest affair; no doubt many have passed over the bridge without noticing its existence. The current bridge was built in 2001, replacing that of 1784. In the older view, buildings of the Lucas Brewery can be seen, the nearest (with slate roof) causing censure when it was built in 1778 by Lucas tenant Samuel Spavold for encroaching on the riverbed. In the modern view, the Malthouse Close development stands on the site. The carvings adorning the doorway of No. 9 Bridge Street, the former café, were added by Belgian First World War refugee Gerard Ceunis, proprietor of Maison Gerard in the Market Place, in 1935.

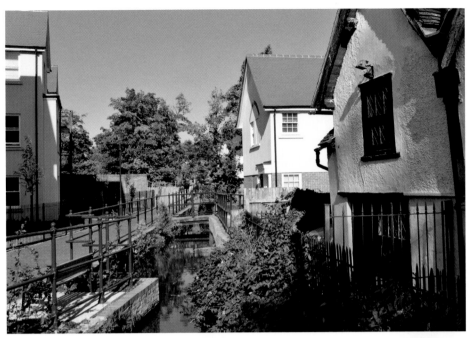

Riverside

A hundred years ago, a row of cottages stood adjoining No. 9 Bridge Street. Known as Riverside, these houses were in the front line when the river burst its banks after 3 inches of rain fell on 23 July 1912. Their outline remains on the north wall of No. 9. Today, new dwellings have been built alongside the river.

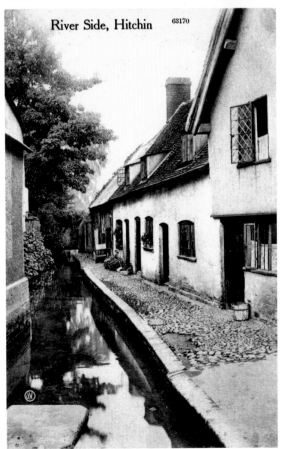

River Side, Hitchin 63170

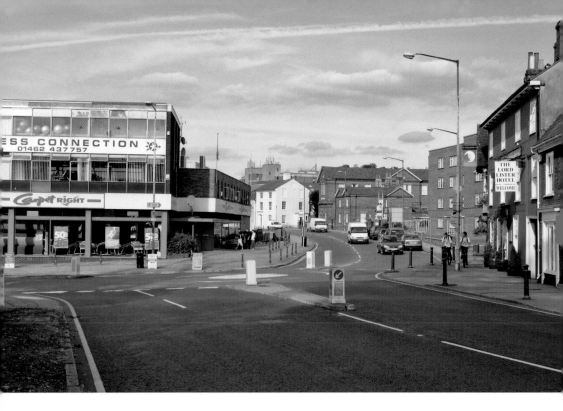

The Triangle

The junction of Bridge, Queen and Park Streets is today formed of a roundabout. It gets its name, however, from the shape of the small railed-enclosure, which reflected the property boundaries of the street. The jettied building facing the camera in the earlier view was once the Bull Inn, which faced the main exit from the town to the south. In the twentieth century, it was the Hill View Hotel & Restaurant, run by A. G. Bottoms. The right-hand section of the building was the home of respected veterinary surgeon W. W. Goldsmith. Already planned for demolition to widen the entrance into Queen Street, it was hit by a coach skidding on ice in 1952. A few years later, the whole row would go to make way for Austin House, constructed in 1963.

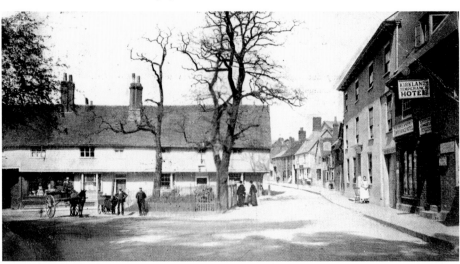

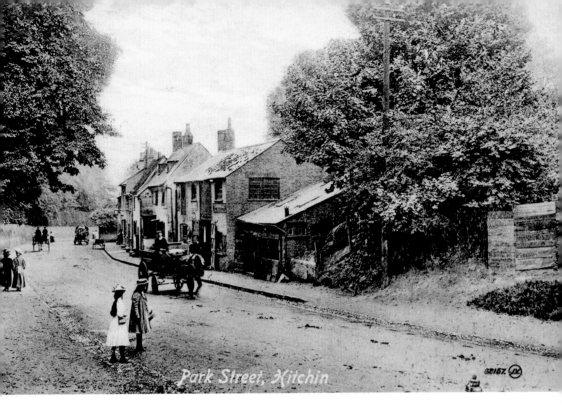

Park Street

Heading south from The Triangle, Park Street was formerly graced by the Falcon pub, whose licensee was also a blacksmith. The high wall on the opposite side of the road marks the boundary of the Priory Park; in the foreground, the road to Preston used to diverge here before the expansion of the park by John Radcliffe in the 1770s.

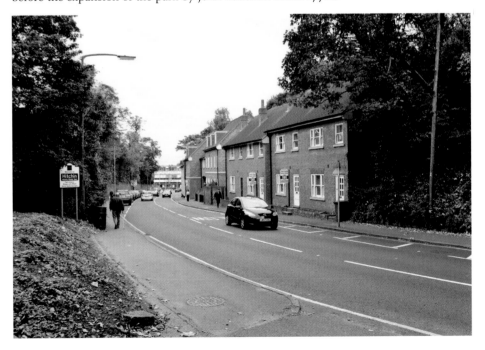

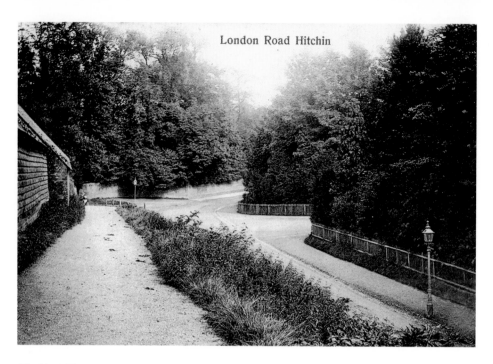

London Road Hitchin

Hitchin Hill

The historic centre of Hitchin is bounded on its south and east sides by steep hills. That to the south was ameliorated by the Hitchin-Welwyn Turnpike Trust in 1806 when a large cutting was excavated. The old photograph shows the junction with Standhill Road to the right and the entrance to the former Preston Road to the left. The excavated road is now known as Hitchin Hill; a hundred years ago Park Street ran straight into London Road.

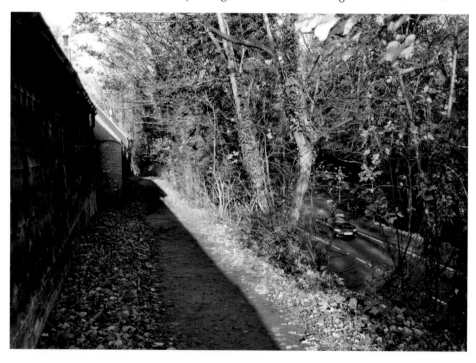

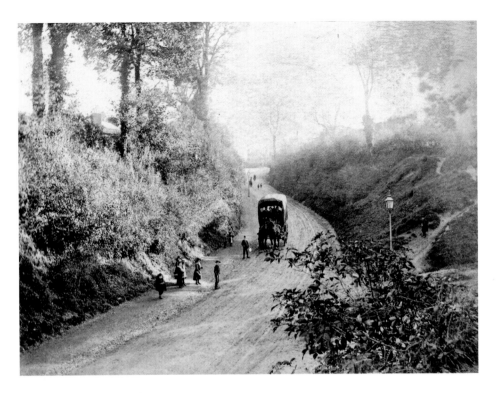

Hitchin Hill *(continued)*

London Road in 1885. The footpath at the top of the cutting towards the Three Moorhens pub can be seen on the right; the turning into Gosmore Road is obscured by a bush. The large house, Greyfriars, would be built at the top of the cutting on the left by the Phillips family in 1903. Today, Gosmore Road has been truncated by Park Way, the section leading off Hitchin Hill being useful for parking.

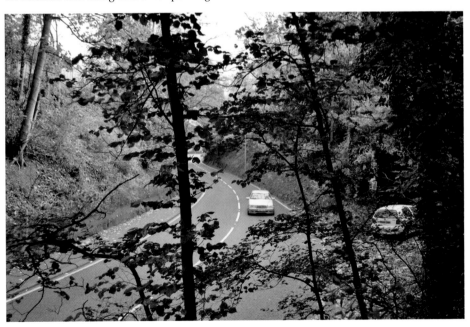

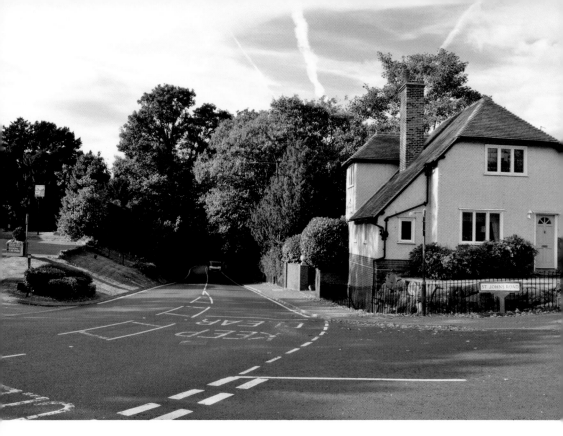

Greyfriars Lodge

The south end of the cutting that is Hitchin Hill is seen from the junction between the 'old London Road' (to Welwyn) and Stevenage Road. Although now the latter is by far the busiest, the street name London Road for the B656 south from Hitchin reflects that route's former primacy compared to the link to Stevenage. The house at the corner of St Johns Road stands at the entrance of the drive to Greyfriars.

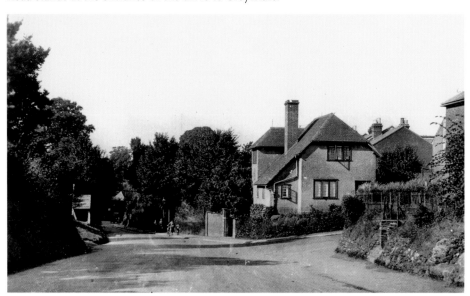

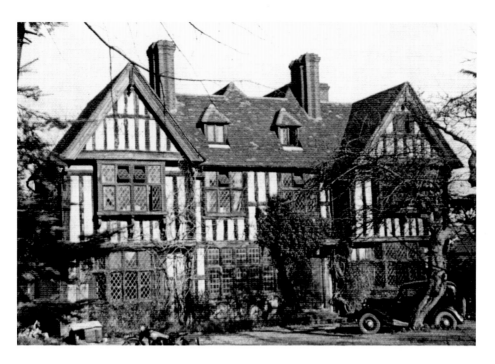

Dower House

The Tudor-style Dower House was built in the 'V' between Stevenage and London Roads in the early twentieth century. It survived the changes made here when the roundabout for Park Way was built at the start of the 1980s, but it has now been replaced by Dower Place flats.

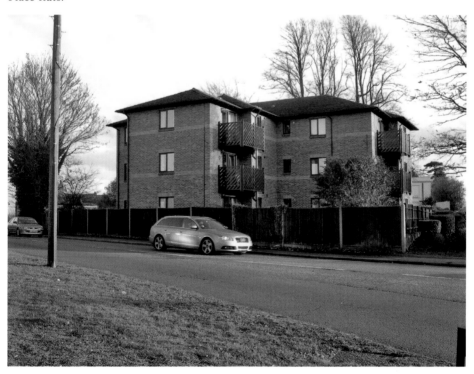

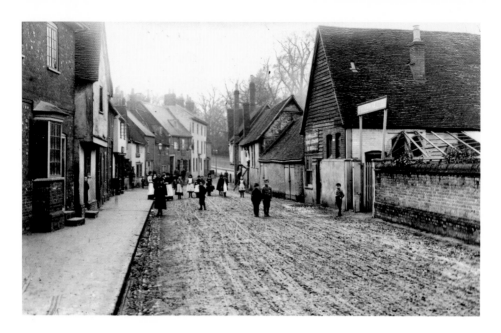

Queen Street

With the Biggin adjoining and a number of ancient buildings spaced along its length, Queen Street, formerly Back Street, contained much of historical significance. However, it was very much the poor relation of the streets of the original town — its southern section seen here was known as Dead Street after the great plague of 1349 and its northern half suffered very badly during the middle years of the nineteenth century when the rapidly expanding population of the town led to many yards of small unsanitary houses being put up and existing buildings were divided into smaller units. The southern half of Queen Street experienced wholesale demolition in the late 1950s. Only one building, which is now the Lord Lister Hotel at the Triangle, survives from the old photograph.

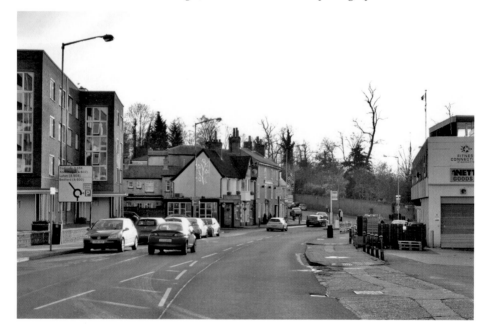

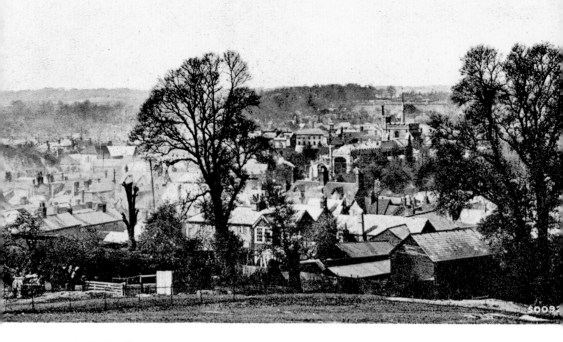

From Windmill Hill

The densely-packed buildings around the entrance to St Andrews Street (now Hollow Lane) and on the site of today's St Mary's Square are seen in the old view from Windmill Hill. Even the *Handbook to Hitchin and the Neighbourhood*, which might be expected to put a gloss on such things, described St Andrews Street in 1899 as 'a very poor locality' and in 1924 work started on clearing away the old cottages, residents being rehoused in the Sunnyside Estate off St Johns Road.

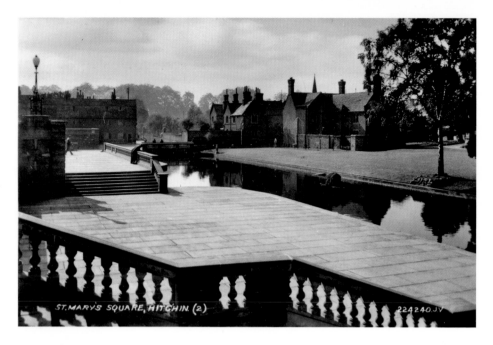

St Mary's Square

The centrepiece of the development of the area around Queen Street was the creation of a large open space where formerly there had been so many houses cheek by jowl — St Mary's Square. At the western edge of St Mary's Square the River Hiz was diverted to run in a straight line closer to the church and elegant balustrades were built from which to overlook the river and church. The houses in Biggin Lane, seen in the distance in the upper view, would be demolished in the 1960s and St Mary's Schools, whose masters' houses are seen to the right of the bridge on the far side of Biggin Lane, would be demolished in 1971.

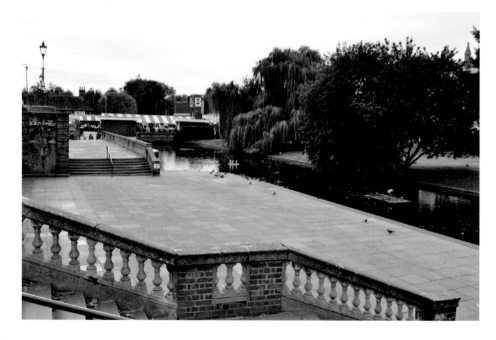

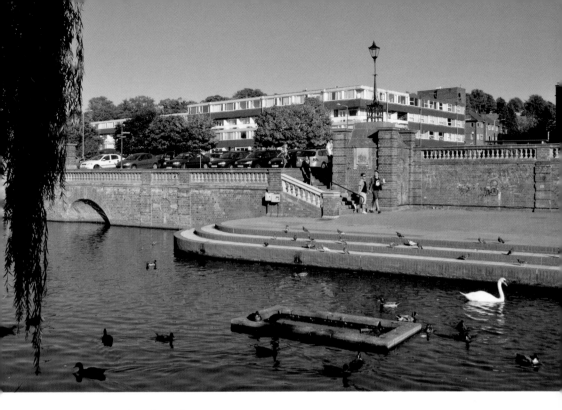

St Mary's Square *(continued)*

St Mary's Square was completed in 1930. Plans were drawn up to surround it on its northern, eastern and southern sides with shops after the style of those built along Hermitage Road. The shops were never built and the Square has become a car park. The market was moved temporarily from the Market Place to St Mary's Square on the outbreak of war in 1939, and it ended up staying for thirty-four years. In 1973, the market was moved to its current site on Biggin Lane and the land where St Mary's Schools formerly stood. At the same time, the pull-in for buses at the north end of St Mary's Square was replaced by a line of stops on the west side of Queen Street alongside the square.

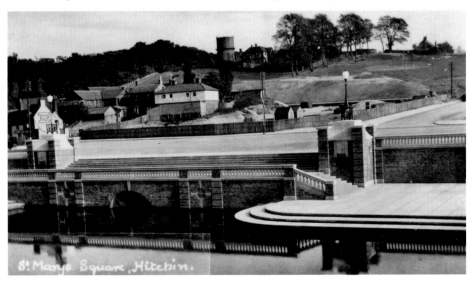

St Marys Square, Hitchin.

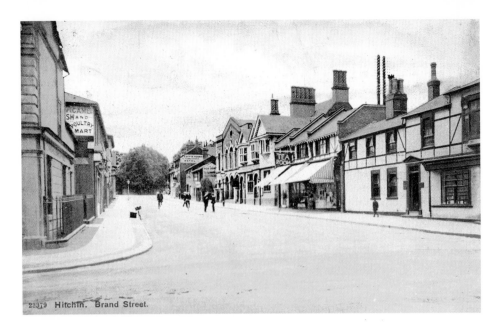

23879 Hitchin. Brand Street.

Brand Street

Originally called Pound Lane, Brand Street was developed in the nineteenth century. In 1840, assembly rooms, which today, along with the adjacent Mechanics Institute library building, form the Ivory bar, were built. A new town hall would be constructed opposite in 1900-02. A new post office, with ornamental chimneys, was built in 1904 next to the Methodist chapel; it would be in use for fifty-eight years. In the 1970s, the chapel and the low-rise buildings next door, which included the Dog pub, were replaced by a Sainsbury's supermarket with multi-storey car park to the rear. This building is now occupied by Argos and New Look.

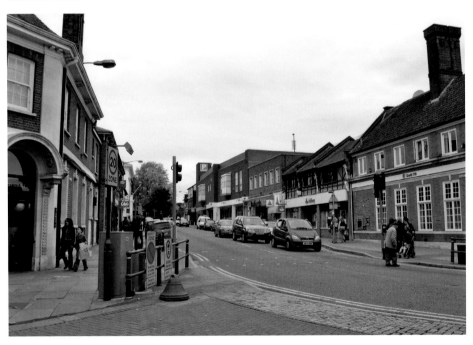

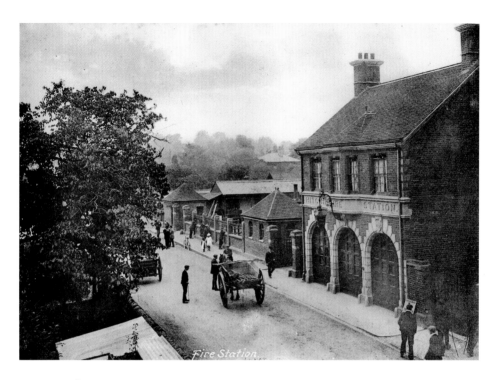

Paynes Park

The earlier of these two views of the road formerly called West Lane is especially of interest as it was taken from the upstairs window of the premises of renowned Hitchin photographer T. B. Latchmore. It shows the livestock market and the fire station, which both came into operation in 1904. Hitchin's livestock market finished in the 1970s and the fire station is now at Newtons Way off St Johns Road. The Cartmann House office block has been built on the site. Latchmore's premises have been replaced by an office block too — called Latchmore Court.

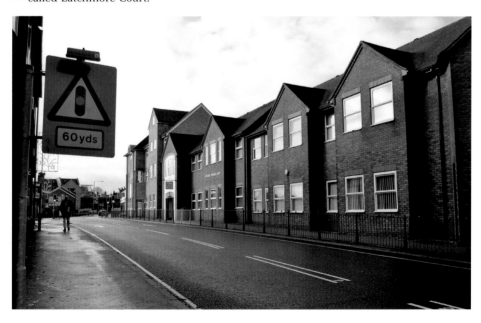

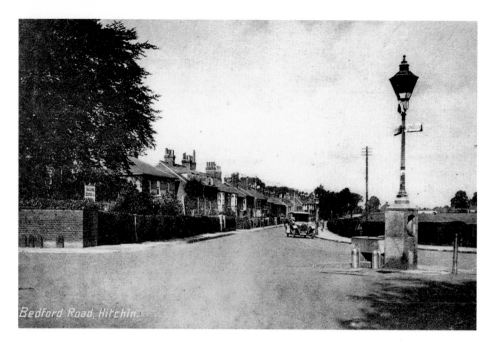

Bedford Road

Bedford Road is seen looking north from the junction with Old Park Road and Oughton Head Way. The first house on the corner is the former home of the Moss family. Nearby, with dormer windows, is the Bedford Arms pub. The line of trees along the western edge of Butts Close looks today as if it has always been there, but the motor age had started before it was planted.

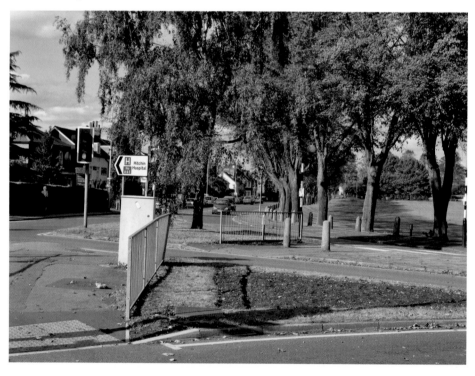

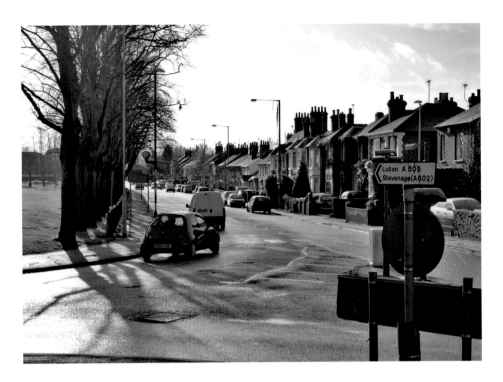

Bedford Road *(continued)*

Villas were erected along Bedford Road during the second half of the nineteenth century. In the earlier view, a delivery appears to be underway at the Cricketers pub. After a few years as the Silver Moon, this became a private house shortly before this book was written. A First World War tank, named *Fearless*, was a feature of Butts Close nearby for twenty years, from 1919, and was mounted on a concrete base.

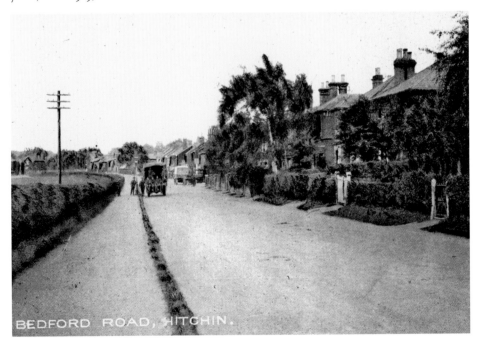

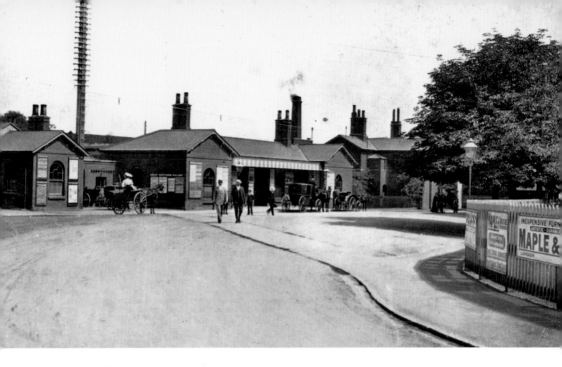

The Railway

There were other factors in the expansion of Hitchin from the mid-nineteenth century, such as the general move away from the land to town living which followed Enclosure of old field patterns and the general economic upswing, but the single most important factor was the opening of the railway in August 1850. Plans for a railway station in Brand Street were put forward, but, in the end, the alignment of the Great Northern Railway caused the station to be a mile north-west of the town centre. The modest station buildings seen in the upper picture soon proved inadequate but were not replaced with the present buildings until 1911.

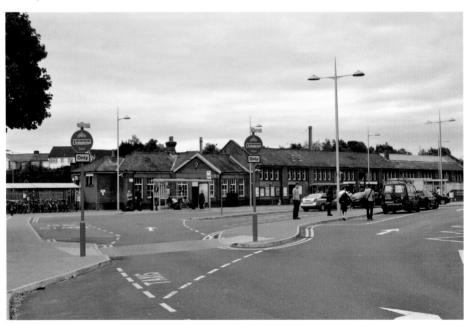

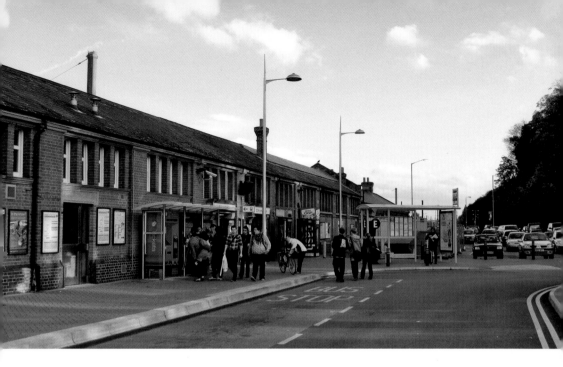

The Railway *(continued)*

The rebuilding of the station featured a large *porte-cochère* or canopy, to allow passengers to alight from vehicles and enter the station without getting wet on rainy days. It survived until the 1970s. Hitchin actually had two railway stations — this one and the Midland Railway's goods facility off Nightingale Road, which opened with the MR's line to Bedford. Passenger trains of the Midland and, later, the LMS always used the platforms of the GNR station. It is worth noting that the dial in the telephone box seen in the lower view described the location as 'Hitchin GNR station' well into the 1980s, sixty years after the GNR had ceased to exist! *Earlier view by Richard Holton*

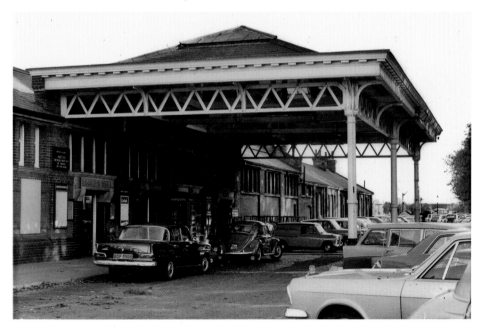

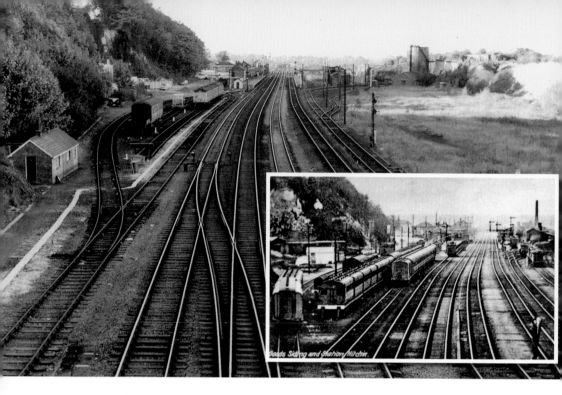

Goods Siding and Station/Hitchin.

From Benslow Bridge

Benslow Bridge and its modern footbridge replacement have provided a great vantage point from which to view the railway over the years. The earliest view shows, to the right, the Great Northern locomotive shed, adjoining the platform for London-bound trains. This closed in 1961 and was replaced by a depot for diesel locomotives to the north of Nightingale Road, which also has now closed. Today, the carriage sidings on the west of the line are used for car parking, and goods, in the form of scrap metal (outgoing) and aggregates (incoming), are handled from the site of the locomotive shed. The points seen in the second view were to allow northbound expresses on the fast line to run into the platform and were removed after Stevenage became the local stopping place for InterCity trains in 1973. *Earlier view by Richard Holton*

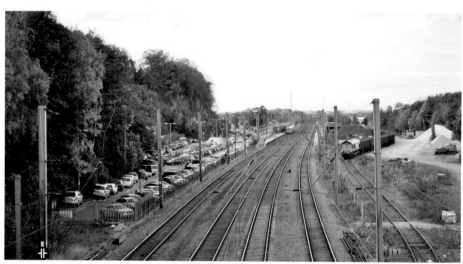

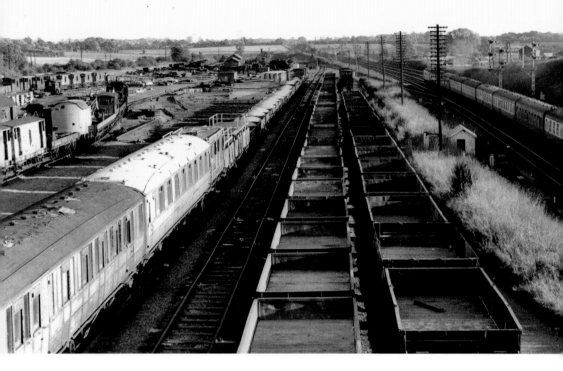

Engineers' Yard

To the south of Benslow Bridge there was, until the 1980s, a large complex of sidings where the railway's civil engineers for the southern part of the East Coast main line were based. The site has been developed for housing, with a number of roads leading from Wedgewood Road, all of whose names have railway connotations. *Earlier view by Richard Holton*

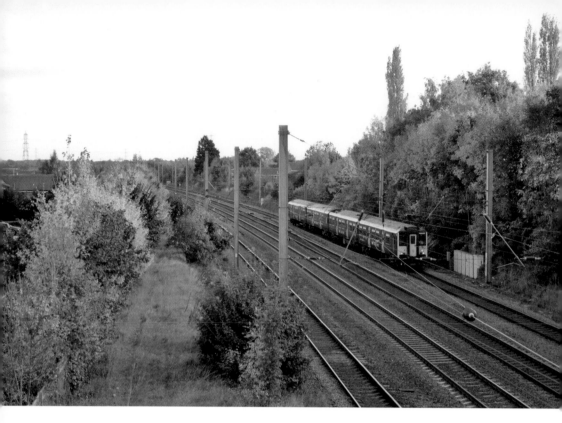

Hitchin South

In the 1970s, the railway between King's Cross and Hitchin was resignalled with colour light signals replacing the traditional semaphores. As part of this scheme, Hitchin South signalbox, seen in 1970, with a train of vans passing, was closed in 1975. Today, there are simply some electronic relay boxes at this point. *Earlier view by Richard Holton*

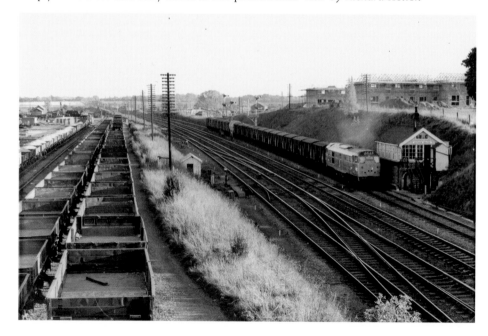

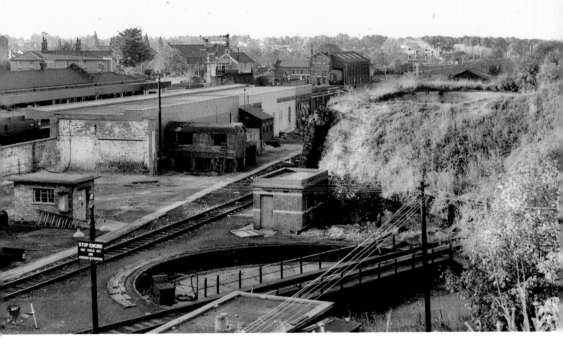

Hitchin Locomotive Shed Site

By 1970, when the upper photograph was taken, the steam locomotive shed had been closed nine years and been demolished. Its turntable remained, however, and has since been moved to the Buckinghamshire Railway Centre for preservation. The site of the locomotive shed is today partially occupied by a mothballed Royal Mail terminal (behind the skip) which was used by Travelling Post Office trains until January 2004. *Earlier view by Richard Holton*

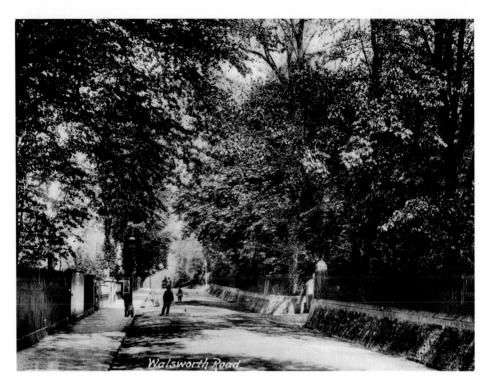

Walsworth Road

The main route from the town to the railway station is Walsworth Road. It has been widened since the upper photograph was taken, but, owing to the former sandpits at The Dell, which are now the home of the Queen Mother Theatre on the right-hand side of the road, this location still presents a leafy appearance.

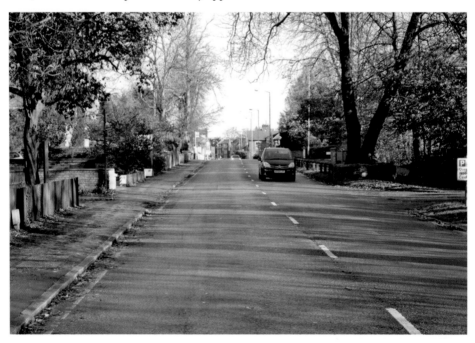

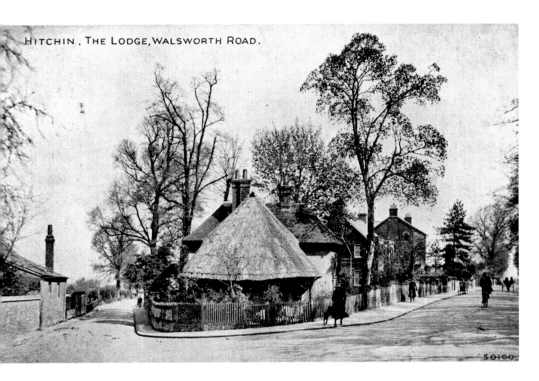

The Lodge, Walsworth Road

Once part of the estate of the Hermitage, this cottage, at the junction of Whinbush and Walsworth Roads, has appeared in many postcard views. It was extended in the early twentieth century, and in 1949 its thatched roof was replaced with tiles of Canadian red cedar. The pine tree in front of No. 5 Walsworth Road, St Lukes, shows the results of 100 years' growth.

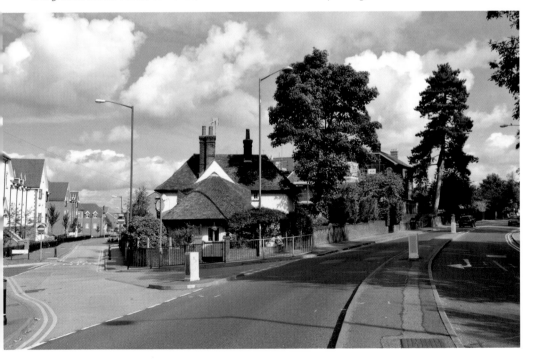

63

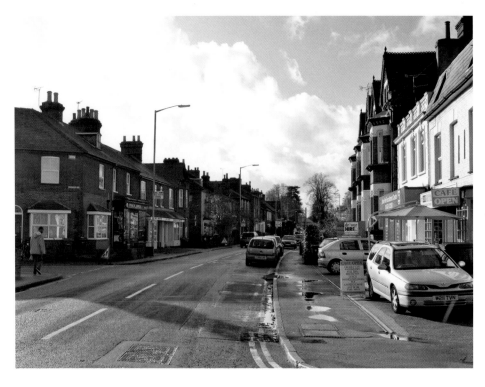

Walsworth Road Junction with Trevor Road

Often referred to as Station Road, including on this postcard published locally by T. Issott, Walsworth Road was quickly developed with brick villas. One house here, No. 47, seen on the far right with a parapet at eaves level, is of national importance as being one of the very first houses built of concrete. It dates from the 1860s and even contains a bath made of concrete! Staff at South East Driver Hire, which occupies the house, confirm that mobile 'phone reception within its walls is non-existent.

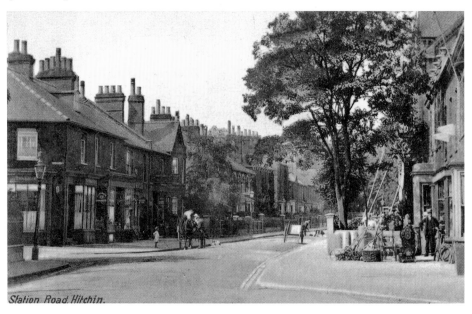

Station Road Hitchin.

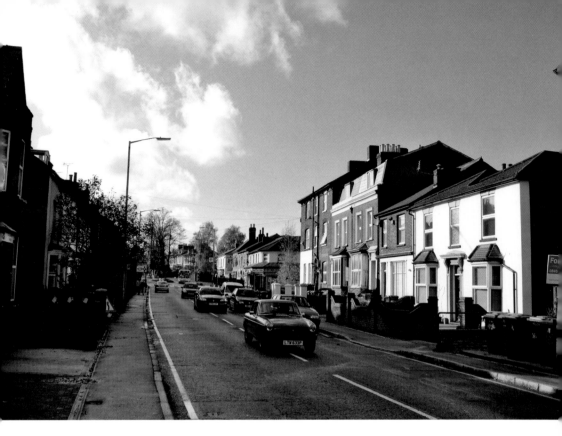

Walsworth Road Looking South

Walsworth Road contains some substantial Victorian houses leavened with a number of shops. Butler's general store and off-licence, nearest the camera and once an outlet for the beers of Fordhams of Ashwell, is now a private house.

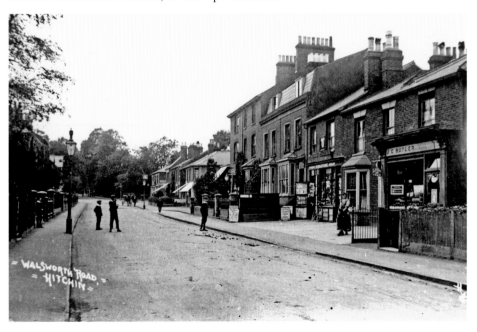

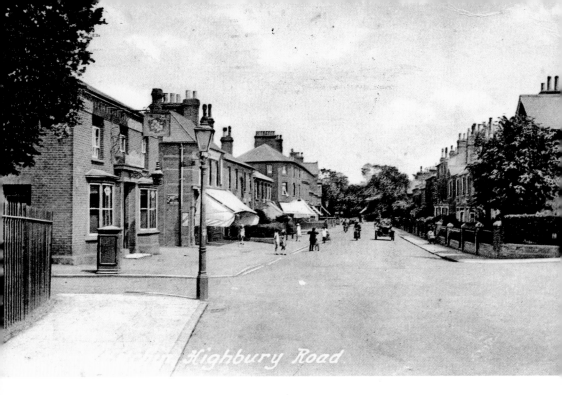

Highbury Road

The Radcliffe Arms

At the point where Walsworth Road is joined by Verulam and Highbury Roads stands the Radcliffe Arms. This pub, named after the Radcliffes of Hitchin Priory, as is the nearby Radcliffe Road, was an early pub in Hitchin owned by J. W. Green, having been acquired before the Luton firm took over W. J. Lucas in 1923. In the 1940s, it was heavily used by staff from the Hartford Works of G. W. King Ltd further down Walsworth Road.

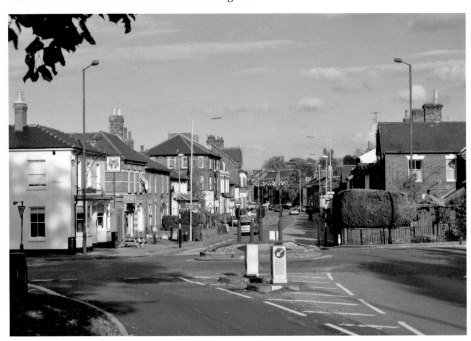

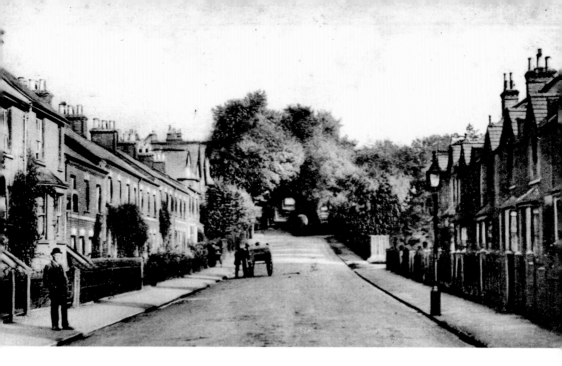

Benslow Lane

Benslow Lane leads eastwards away from Highbury Road and would appear to be an unremarkable street of Victorian housing. However, it played a pivotal role in the development of Cambridge University and sexual equality in general — Girton College, the first college of the university to admit female students, began here at Benslow House, located at the top of the road on the left, before it becomes a leafy lane. It was opened by Emily Davies in 1869 as the College for Women, with five students, and by the time it moved to Girton, which is just outside Cambridge, four years later it had fifteen enrolled. It was only in 1881 that women were allowed to sit the university's examinations, and it would not be until 1948 that women were admitted to full membership of Cambridge University.

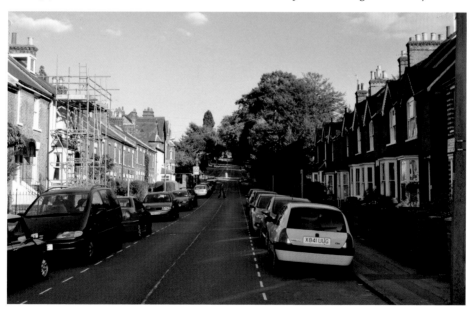

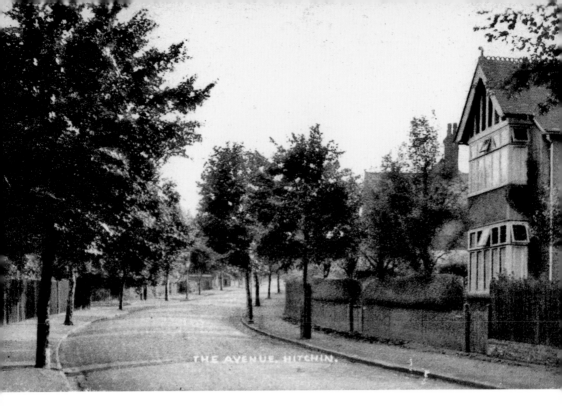

The Avenue

The Nettledell Estate of large villas was built to the south of Benslow Lane and tended to house wealthy commuters who were just a few minutes' walk away from the railway station. The Avenue, running eastwards from Highbury Road, is at the centre of the Nettledell Estate and truly lives up to its name.

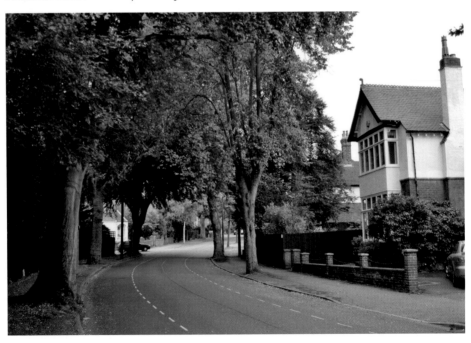

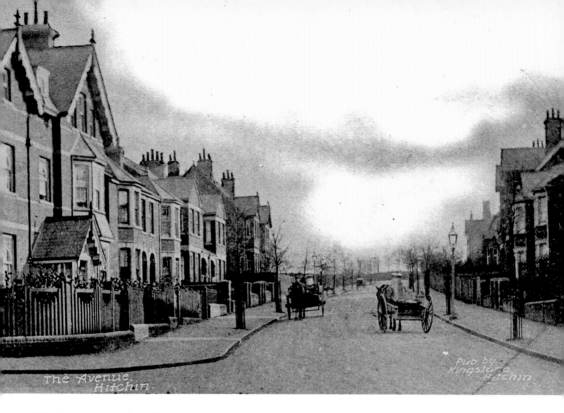

The Avenue *(continued)*

The upper half of The Avenue looking towards Wymondley Road from the corner of Chiltern Road. Not all the residents were commuters: G. W. Carling, whose company published the *Hertfordshire Express* newspaper from Exchange Yard off the Market Place, lived here in the 1950s. Today, some of the houses have been subdivided into flats, such as the house behind the pillar box, but the road remains one of the more sought-after addresses in the town.

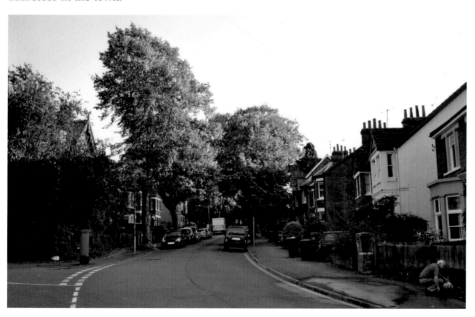

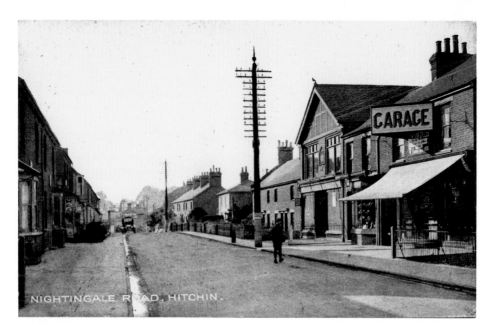

Nightingale Road

When the railway opened, Nightingale Road was just a rough lane containing a couple of cottages, a far cry from today's busy A505. Development was rapid, and the building with the mock timber-framing to its gable was built in 1901. The building nearest the camera on the right was, until very recently, E. T. Cherry & Sons hardware shop, complete with its own petrol pump. It has been converted to housing. In the distance of the current photograph, the gable end of the Orchard & Anvil pub at Starlings Bridge can be seen. Known as the Woolpack for most of its life, it was closed at the time of writing.

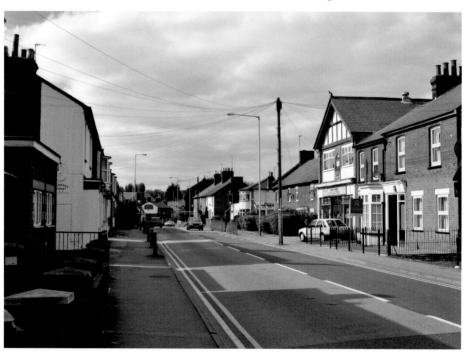

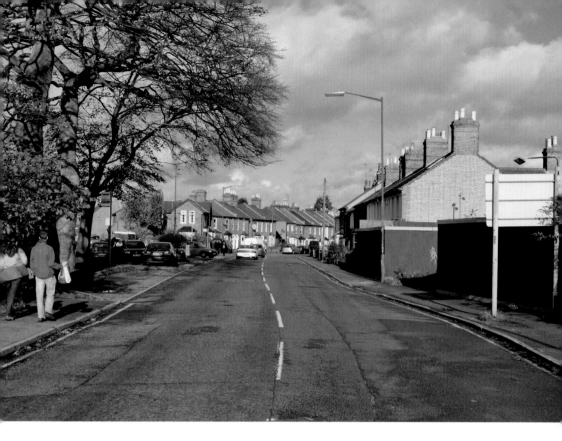

Grove Road

Today, Grove Road, heading north from Nightingale Road at Starlings Bridge, is a main artery to the industrial area around Cadwell Lane and Wilbury Way, to which several old Hitchin firms from the town centre have relocated. In the mid-nineteenth century, it was just a footpath. The junction with Baliol Road and Water Lane branches off to the left.

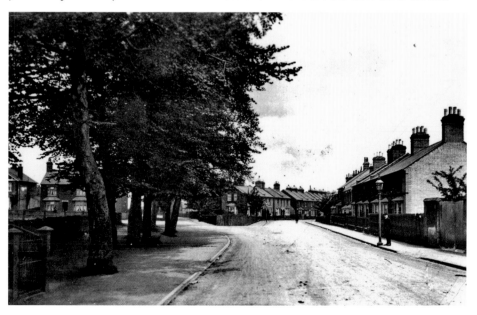

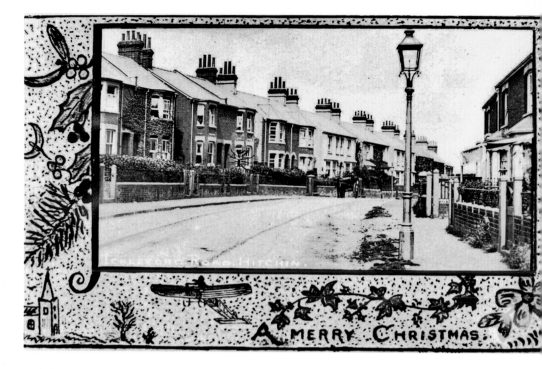

Ickleford Road

Hitchin's first roundabout is at the junction between Nightingale Road, the north end of Bancroft, Fishponds Road and Ickleford Road and it dates from the 1930s. Another first for Ickleford Road was the town's earliest cinema, Blake's Picturedrome, opening in 1911 and which today is the Royal Quarter residential development. This view is of further up the street and illustrates the detailed changes of a ninety-year span.

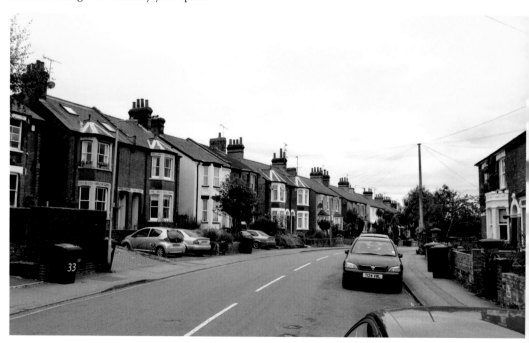

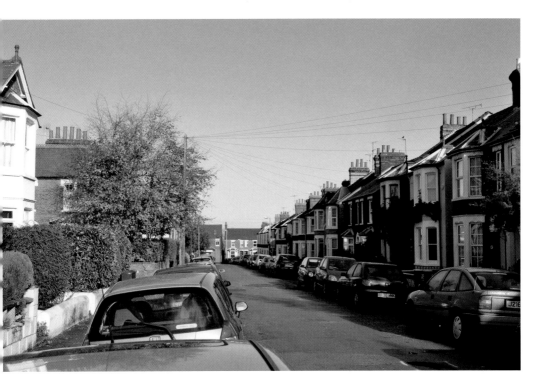

York Road

The Hitchin building firm of M. & F. O. Foster of York Road was one that thrived on the expansion of the town in the late nineteenth century. York Road is seen looking north from the junction with Lancaster Road towards Bearton Road.

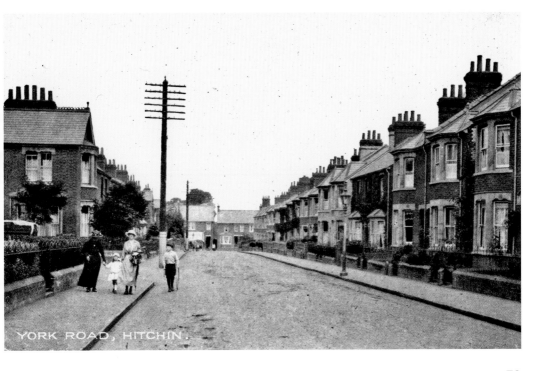

YORK ROAD, HITCHIN.

Hermitage Road

For nearly twenty-five years from the opening of the railway, the most direct route§ from the centre of the town was along Portmill Lane, into Queen Street and then along Walsworth Road. This changed in 1874 when Hitchin banker and philanthropist, Fredric Seebohm, who lived at the Hermitage in Bancroft, donated a large part of his garden for a new road leading east to the point where Queen Street ran into Walsworth Road at the bottom of Windmill Hill. This road was to be called Hermitage Road, and in the earlier view, the end of the Hermitage can be seen. This house was an amalgam of various buildings, including a barn, and most of it was demolished when shops were built along Hermitage Road in the late 1920s. Some stained glass window panes from the Low Countries, which had been installed in the Hermitage by Seebohm, were saved, and they are now in the first floor window above the entrance to Clement Joscelyne. The pane shown depicts what is believed to be the coat of arms of Abraham Wildey Robarts of Berkeley Square, London, MP for Maidstone, who died in 1858.

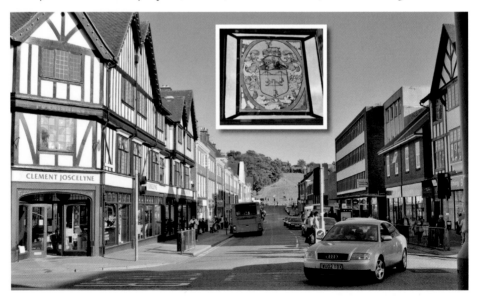

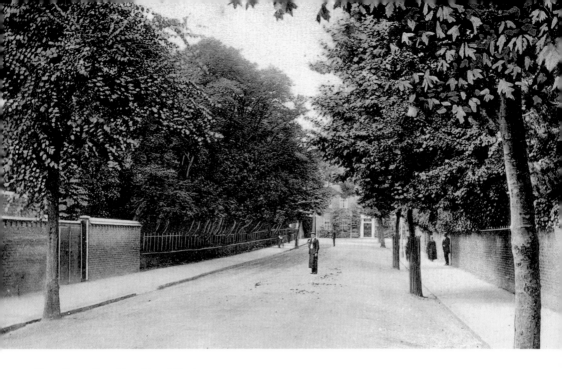

Hermitage Road Looking West

In its early years, Hermitage Road was characterised by its trees. The box trees seen by the railings were said to be of great antiquity, dating back to the reign of Edward IV (1442-1483), and there was a public outcry during the First World War, led by Reginald Hine, when their removal took place. Ickleford Road runs north from the Blakes Corner junction at the top of Bancroft. The house facing the west end of Hermitage Road, No. 10 Bancroft, belonged to the Waters family. It was demolished in 1967 and a Safeway supermarket, now a Wilkinsons, was eventually built on the site.

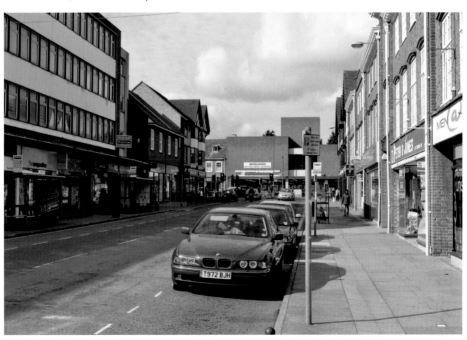

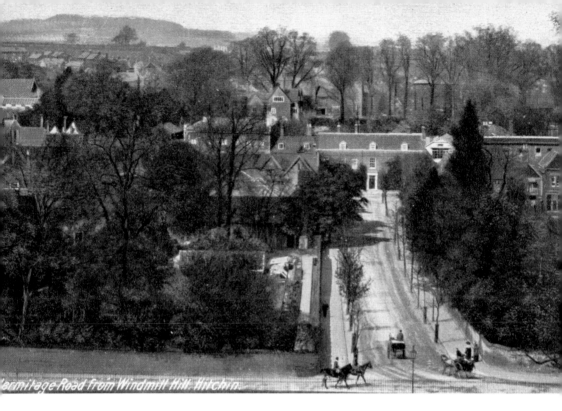

Hermitage Road from Windmill Hill. Hitchin.

Hermitage Road from Windmill Hill

Enormous change is encapsulated in these views a century apart, taken from Windmill Hill, which was itself once part of the Hermitage estate. Some features remain, notably the roof of the town hall in the middle distance on the left, while, although obscured by the shops at the east end of Hermitage Road, the brick-built northern wing of the Hermitage, seen on the far right of the earlier view, is still standing.

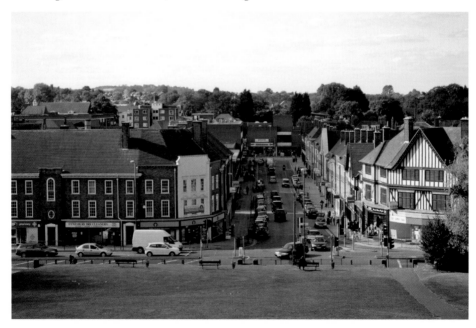

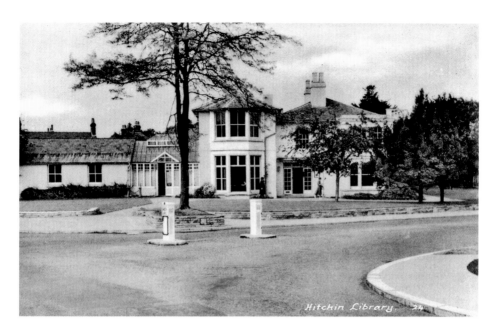

Museum and Library

The large house in Paynes Park that is now Hitchin Museum was built in 1825 by George Kershaw. Much extended over the years, and named both *Agadir* and *Charnwood* at different periods, it had been used by the Royal Engineers during the First World War. It was donated to the town by the Moss family, and in 1938, the County Library moved here from Brand Street. Three years later, Hitchin Museum opened upstairs. In 1965, a new library building was built on the west side and the museum took over the whole house. In the modern view, the mural, which was formerly on Sainsbury's in Brand Street and now on the front wall of the library, can be glimpsed through the trees.

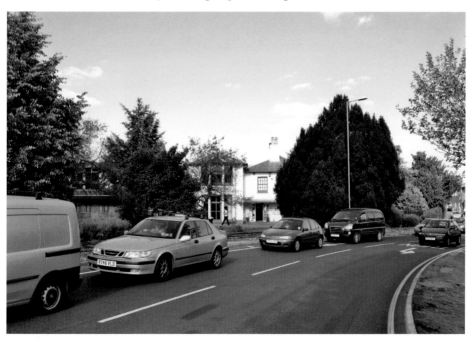

Chalk Dell

The area to the west of Bedford Road has received seemingly little attention from historians, but it has an interesting story. Dominated, inevitably, by the workhouse of the Hitchin Union, this area features a large green on Oughton Head Way. This has not always been the case, as the green was, in the nineteenth century, a large quarry, Chalk Dell, which was gradually filled in with debris over the years to create the green of today. The two cottages on the right of the earlier view remain, no longer perched close to the edge. *Earlier view courtesy of Mr & Mrs R. Spicer*

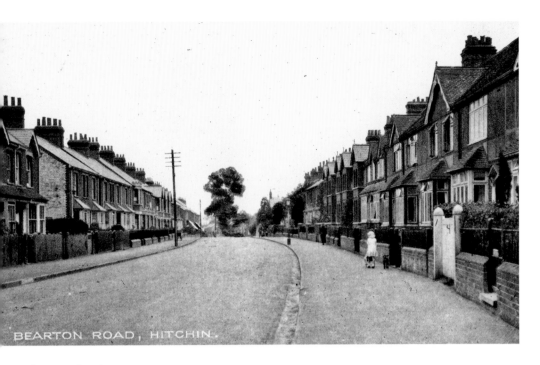

Bearton Road

By the turn of the nineteenth and twentieth centuries, the residential development of Hitchin had reached a mile north-west of the Market Place. As elsewhere in the town, while telegraph poles undergo periodic replacement, they tend to be at the same location.

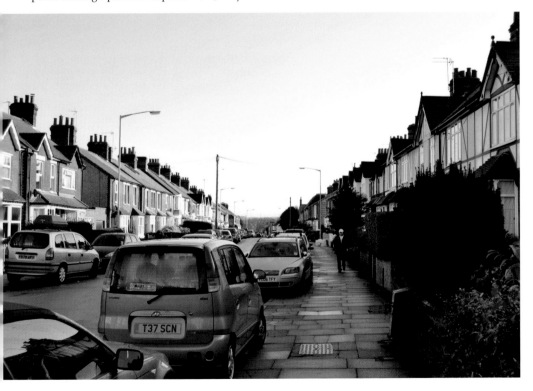

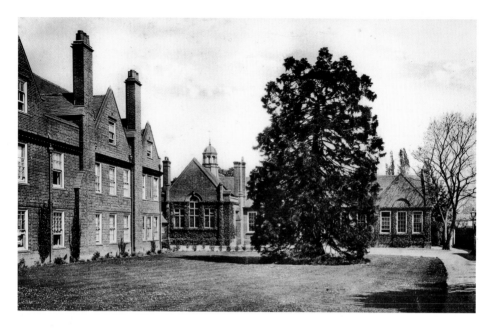

Hitchin Boys' School

Hitchin Boys' School has its origins in the seventeenth century with the foundation of the Free School by John Mattocke. After a hiatus during the 1870s and 1880s when the Free School had fallen out of use, the Boys' Grammar School began on land at the rear of The Woodlands 120 years ago and has remained there every since. Approached by road from Grammar School Walk, leading from the Bedford Road/ Brand Street/ Paynes Park junction, the school made the change from grammar to comprehensive in 1974, and its alumni include Sir Peter Bonfield, CBE, former chairman of BT and the news reader, actor and author Richard Whitmore, who attended from 1943 to 1950.

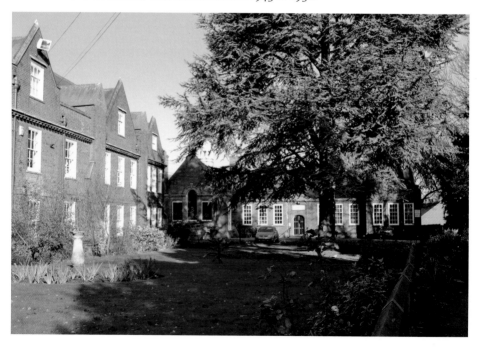

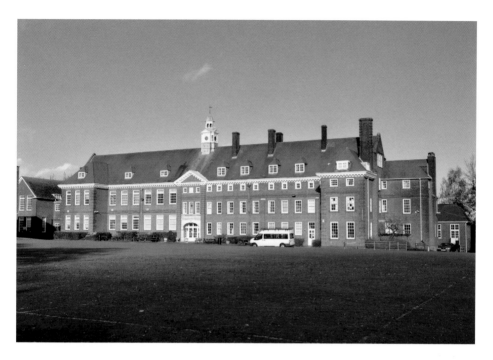

Hitchin Girls' School

The Girls' Grammar School soon outgrew its home at The Woodlands — in 1908 an impressive new building was erected by the Hitchin building firm John Willmott at a commanding location on Highbury Road. The school has been extended at various times since, but the impressive southern frontage facing the playing field remains exactly as its creators intended.

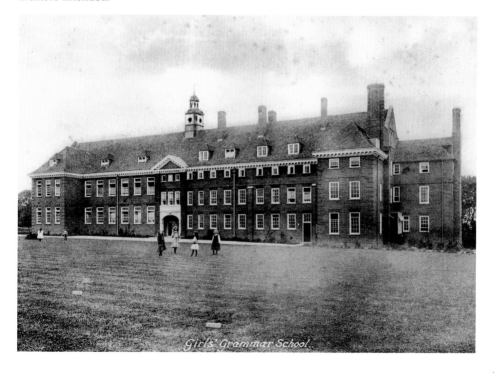

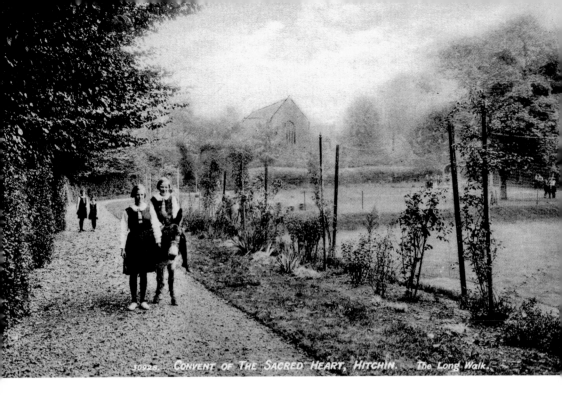

30928. CONVENT OF THE SACRED HEART, HITCHIN. The Long Walk.

Sacred Heart Convent

The Convent High School of the Sacred Heart stood on Verulam Road. This view of the grounds is today the residential road Convent Close; the only factor common to both versions is the outline of the Baptist church in Walsworth Road, which was constructed by Richard Johnson, chief engineer of the Great Northern Railway.

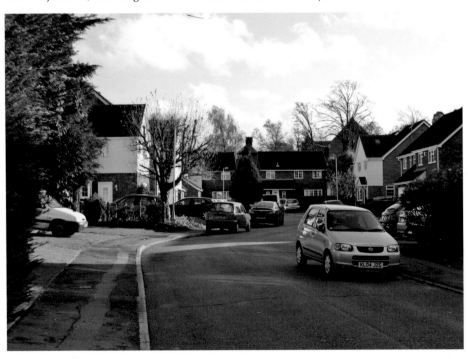

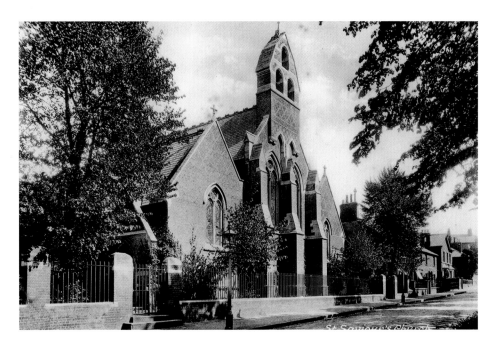

St Saviour's Church

The story of the Church of the Holy Saviour in Radcliffe Road has a less direct link to the Great Northern Railway than that of the Walsworth Road Baptist church, but it is nonetheless the result of the arrival of the railway. Although St Mary's is very capacious — it is said to be the largest parish church in Hertfordshire — the new roads near the station were a long way from the town centre. St Saviour's was completed in 1864 and soon required extensions to cater for its growing congregations, which in the later years of the nineteenth century were swelled as some found the location of St Mary's close to the crowded and noisome dwellings off Queen Street to be less than salubrious.

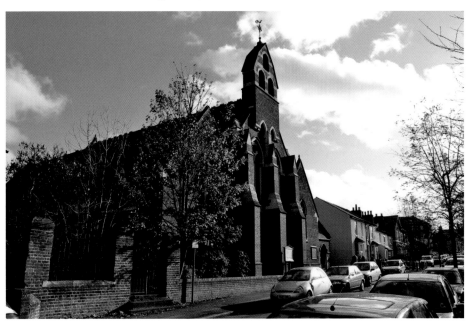

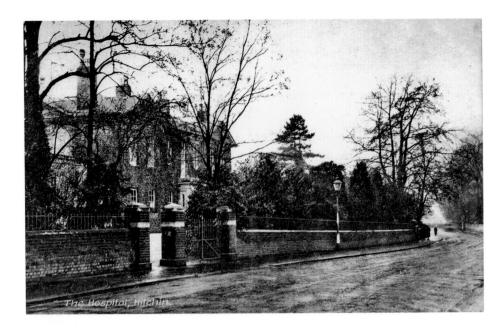

The Hospital, Hitchin

Hitchin Infirmary

Hitchin's main claim to medical fame is the fact that Joseph, later Lord, Lister spent the early years of his life in the town. Indeed, the private school he attended at The Triangle is now named the Lord Lister Hotel in his honour, and when a second hospital was built at Chalk Dell it was also named after him. The Hitchin Infirmary, seen here, was the town's first hospital and was founded in Bedford Road by Dr Frederick Hawkins in 1840. By the time of the upper photograph, it had become the North Herts & South Beds Hospital and was greatly expanded in 1929. The extensions were opened by HRH The Duchess of York, who had many Hitchin connections and had attended a private school in Radcliffe Road. When the Lister Hospital moved to Stevenage, leaving the Hitchin location to be known as the Hitchin Hospital, she would open the new facility in 1972, by then as the Queen Mother. The old infirmary, minus its extensions, still stands.

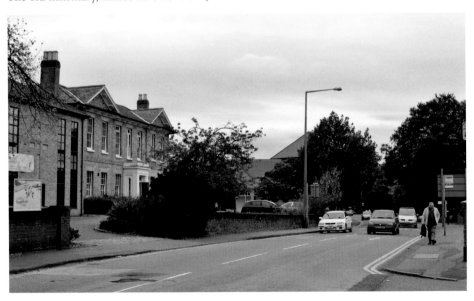

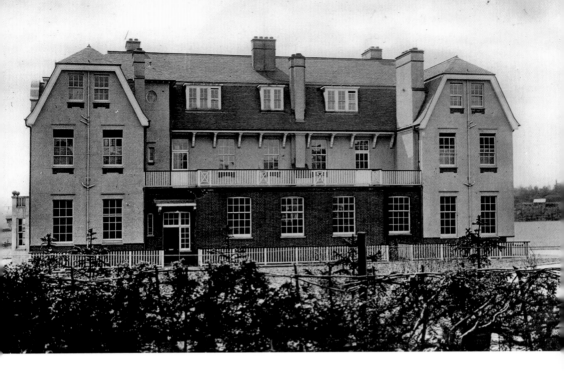

Pinehill Hospital

Today's Pinehill Hopsital, at the top of Benslow Lane, started life in 1908 as the convalescent home for the German Hospital at Dalston, East London. Its foundation stone was laid by Princess Louise Augusta of Schleswig-Holstein. The First World War put an end to the German connection, and in the 1950s, it was part of the National Health Service under the Luton & Hitchin Group Hospital Management scheme as Hitchin Convalescent Home. Today, it is part of the private healthcare sector.

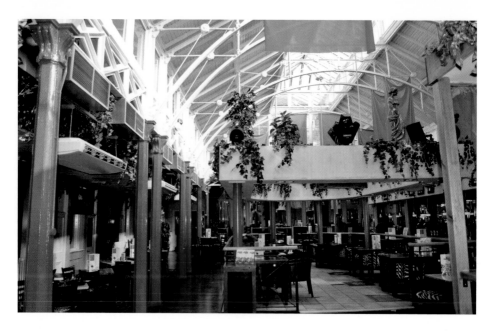

Corn Exchange

The coming of the railway saw Hitchin develop as a grain market, this being spurred on by the opening of the Corn Exchange in 1853. Grain dealers travelled from far and wide to trade at the Exchange, which, along with the premises of Thomas Perkins, replaced the glorious old inn the Red Lion, which, luckily for posterity, was captured in a magnificent painting by Samuel Lucas. The office of T. W. & P. Franklin, to the right of the main entrance, was a fixture of the Market Place for generations. Use of the Corn Exchange declined, and when trading was not being undertaken, it was used as roller skating rink. Finally, it became a showroom for camping goods, before a period in the 1990s as a craft market. Today, it is the Que Pasa bar. The engraving dates from its opening and appeared in the *Illustrated London News*. Clearly, there have been some alterations to the roof since 1853.

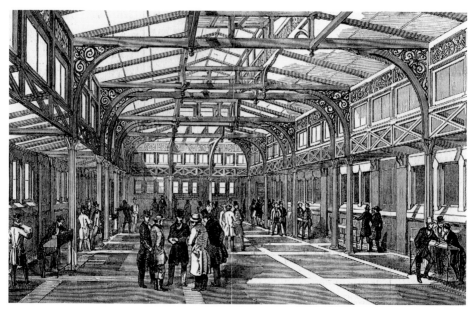

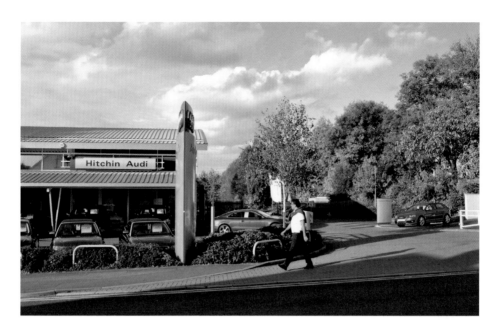

Bacon Factory

The Herts & Beds Farmers Co-operative Bacon Factory opened in Nightingale Road on 17 April 1913. A landmark in pork processing, it was the first all-English co-operative bacon factory and cost £20,000 to build. Opened by Lord Lucas, parliamentary secretary to the Board of Agriculture, it was designed to deal with 15,000 pigs a year. There was a shop on site, seen here, as well as a shop in the Market Place, with branches in other towns in Hertfordshire. It was in operation until the 1960s; after demolition, the land was used for the Station House office block, but that was rather short-lived and now Hitchin Audi occupies the site.

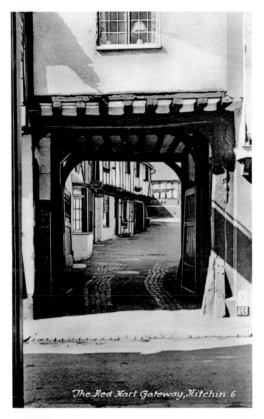

The Red Hart Gateway, Hitchin 6

Red Hart Gateway

The Red Hart in Bucklersbury vies with the Cock for the title of the town's longest-surviving inn. Its yard, for many years in the twentieth century the home of Boxalls Taxis, is accessed through a picturesque gateway.
The gates are thought to be of early seventeenth-century date: they have open upper panels that are set with pierced balusters.

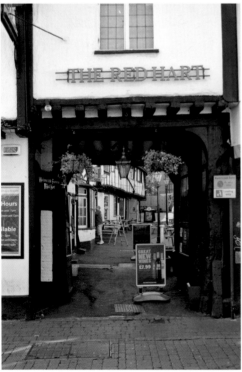

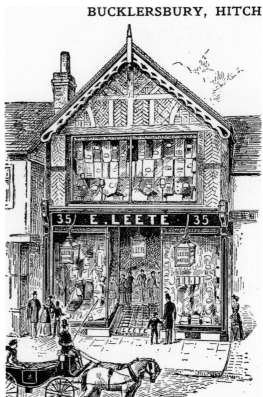

Bar Mezé

In the eighteenth and early nineteenth centuries, the owners of timber-framed buildings were often keen to add a brick façade to their premises, giving them a more contemporary appearance. By the late nineteenth century, timbered frontages were back 'in' and studwork began to be revealed, even if it were not originally intended to be seen. New buildings began to be built presenting timber-framed frontages, a good example of which is No. 35 Bucklersbury. In 1899, the recently erected building was the outfitters shop of Ernest Leete; since 1996, it has been the Greek restaurant Bar Mezé.

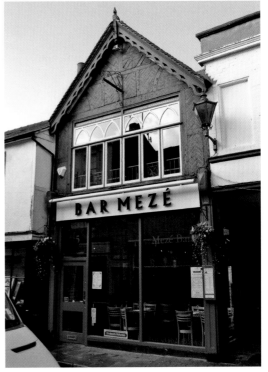

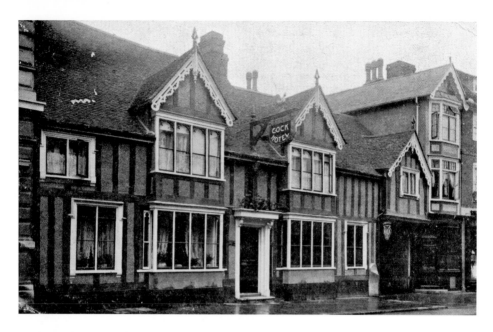

Cock Hotel

The milepost recording the fact that Hitchin is 34 miles from London was formerly beside the gateway of the Cock. The earlier view is from a promotional postcard issued by the Cock around 100 years ago when Alfred Doughty was the licensee. It was during Mr Doughty's tenure that the three-storey wing at the north end of the Cock was constructed. In the early 1930s, Simpsons Brewery decided to sell off the greater part of the Cock's curtilage and a branch of Woolworth's was built. In the 1960s, a larger branch of Woolworth's was built on the other side of the Cock, leaving the first Woolworth building to become Timothy White's chemist and ultimately Boots.

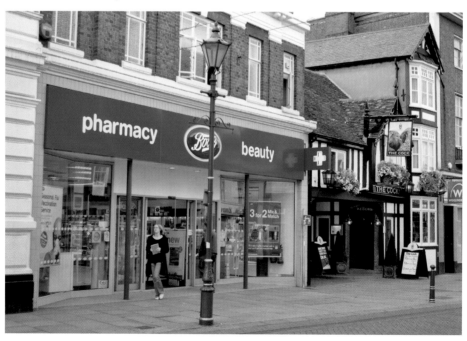

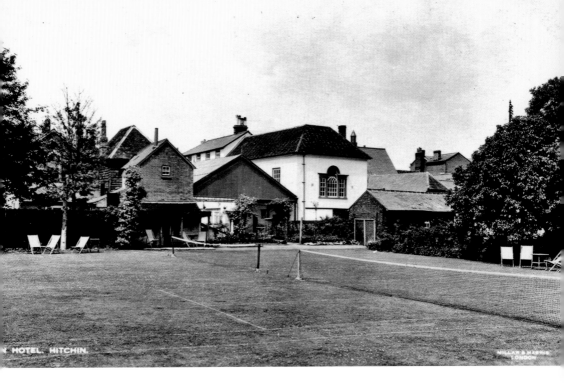

HOTEL, HITCHIN.

Behind the Sun

The extensive grounds at the rear of the Sun Hotel included tennis courts, seen in the earlier view from the waterworks in Queen Street. The old photograph also shows the glass roof that, for some decades, enclosed the yard of the Sun. The Churchgate development in the 1970s led to a less verdant use for the land, which is now accessed from Biggin Lane.

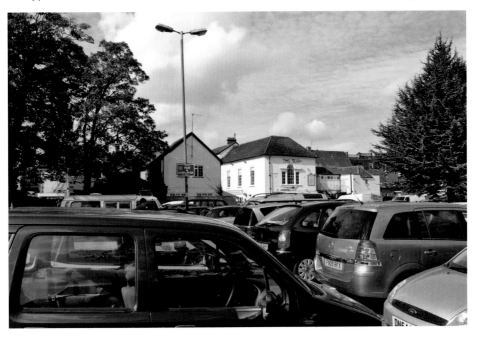

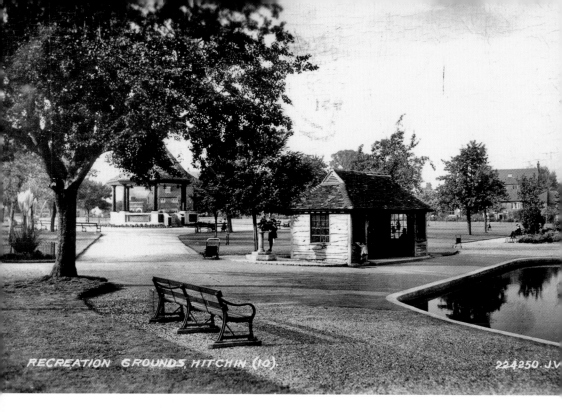

RECREATION GROUNDS, HITCHIN (10). 224250.JV

Bancroft Gardens

Once used as osier beds and then as a dairy farm, the land bounding the western end of Nightingale Road between the north end of Bancroft and the River Hiz at Starlings Bridge was opened as Bancroft Gardens in 1929. The pear tree in the foreground predates the laying out of the gardens; Frythe Cottages at the start of Nightingale Road can be seen through the bandstand.

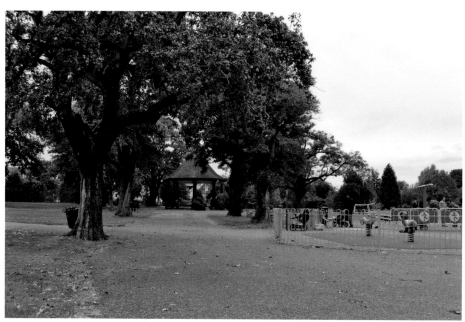

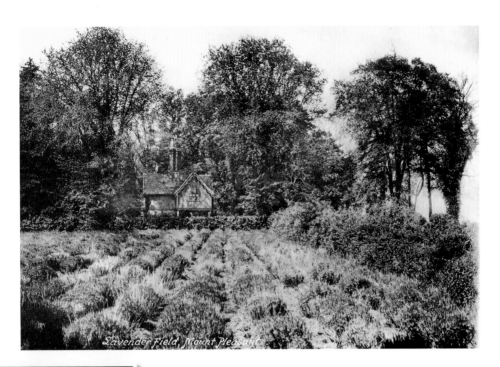

Lavender Field, Mount Pleasant

Mount Pleasant

Hitchin was well known for its lavender, the main producer of products using lavender being Perks, latterly Perks & Llewellyn, of No. 9 High Street. In recent years, lavender production has been revived at Cadwell. For many years, Perks & Llewellyn grew lavender in a field at Mount Pleasant off the Pirton Road — this view of the field with the cottage behind served as the company's trademark and was a feature of its labels and advertisements for at least fifty years. Today, Mount Pleasant is a cul-de-sac of houses.

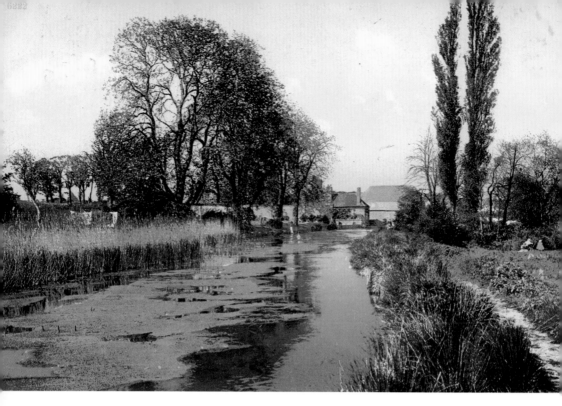

Westmill

Westmill lies at the north-western edge of the parish of Hitchin. Before flowing into the Hiz, the River Oughton ran into a large millpond from which the mill was powered. The mill ceased to be used in the 1920s; its buildings burnt out in 1961 and have been converted to houses.

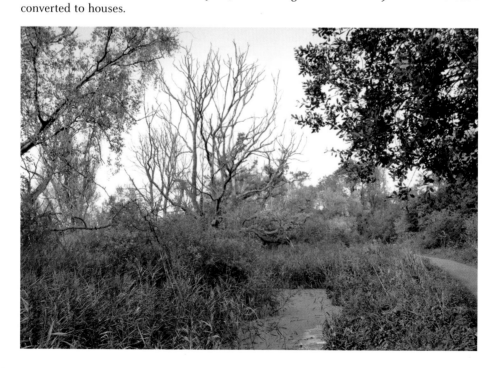

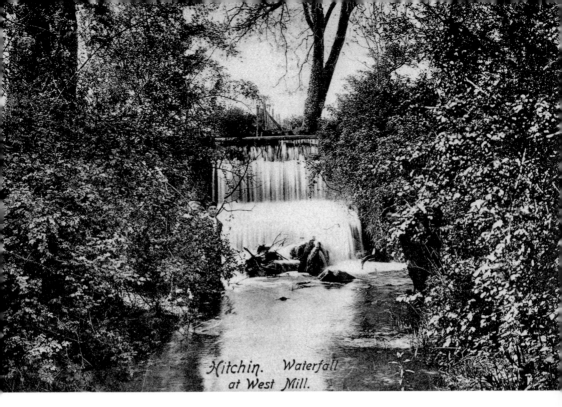

Hitchin. Waterfall at West Mill.

The Waterfall

The geology of the Hitchin area makes a real waterfall impossible, as there is no hard rock formation for water to run off. However, the outshoot from the millpond at Westmill has long been described as Hitchin's waterfall and flows impressively today.

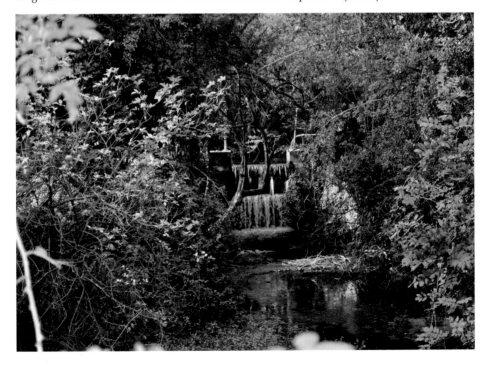

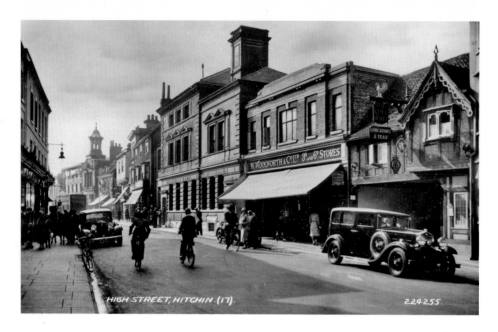

Woolworth's

The twentieth-century history of the Cock is, in many ways, a microcosm of that of Hitchin through time. Dating back centuries to an indeterminate point, the Cock underwent great change when Woolworth's arrived, yet with time even Woolworth's attracted some of its own lustre to add to the Hitchin story. It proved a great attraction to the writer George Orwell, who was a regular visitor on his bicycle during the years when he lived at Wallington near Baldock and it has another celebrity association: during the early part of the Second World War the actor Leslie Philips worked there. In the long term, like the town itself, the Cock, although changed, has survived, outliving both Woolworth stores, and hopefully will continue to do so.

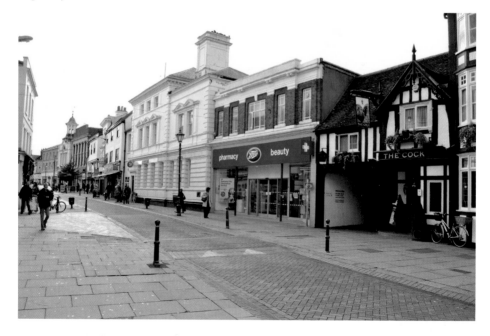